Watercolour Tips and Tricks

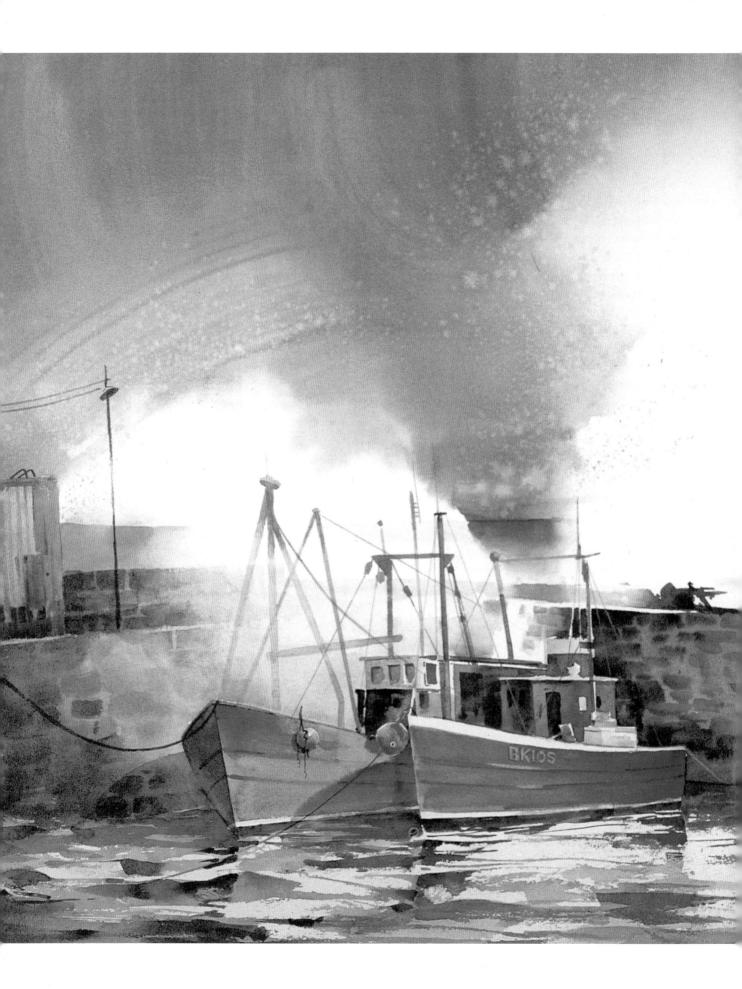

Collection of Willa McNeill

Watercolour Tips and Tricks

Zoltan Szabo

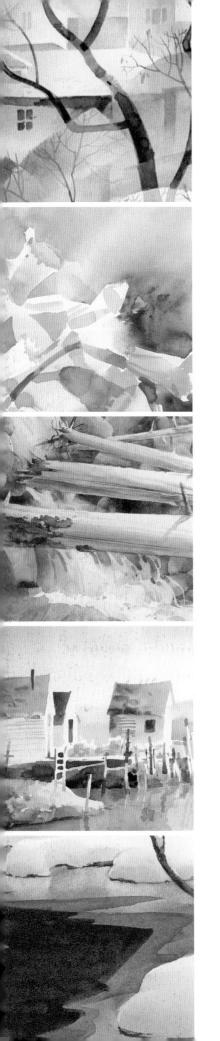

Contents

Introduction, 6 My Favorite Tools, 10

Qualities of Transparent Watercolor Pigments, 12

Transparent Colors, Opaque Colors, Reflective Colors, Sedimentary Colors, Staining Colors, Nonstaining Colors, Dominance, Staining Dominance, Palettes

2

The Rules of Reflection, 24

Characteristics of Waves, Ten easy-to-use rules that will help you paint reflections accurately, including reflection angles, color, value and perspective

3

Composition and Design, 36

The Illusion of Space, Graphic Symbols, Path of Vision, Planes

4

Basic Techniques at a Glance, 44

Wet-and-Blot Lifting, Lost and Found Edges, Back Runs, Charging a Wash, Brush Handle Scraping, Using a Palette Knife, Lifting Out Color, Luminous Opaque Colors

5 Watercolor Techniques for Painting, 50

Wispy Clouds, Cumulus Clouds, Stratus Clouds, Dramatic Clouds,
Birch Trees, Pine Branches, Lifted White Trees, Weeds, Flowering Trees,
Jagged Granite Rocks, Rounded Glacial Rocks, Rolling Surf, Puddle
Reflections, Shadows on Snow, Sunlight on Snow, Warmly Lit Snow,
Falling Snow, Trees in Heavy Snow, Young Spruce in Snow, Heavy Fog,
Mist, Sunlight on Wood, Cobweb, Simplified Planes, Background Forest,
Winter Island, Rolling Snowbanks, Ice on Trees, Frost on Trees, Setting
Sun, Negative Shapes, Charged Washes, Colorful Darks, Smooth Tree
Bark, Rough Tree Bark, Glazed Tree Bark, Tree Impressions, Rock Setting,
Palette Knife Trees, Brush Handle Trees, Soft Lifted Trees, Wet-into-Wet
Evergreens, Sunlit Mountain Tops

6 Painting Demonstrations: A Step-by-Step Gallery, 108

Flowers: Glazing with Staining Colors, Icy Creek: Glazing and Lifting, Shadows on Wood: Staining Texture and Lifted Sunlight, Autumn Colors: Controlling Edges, Misty Day: Wet-into-Wet Reflections, Fallen Timber: Emphasizing Texture, Fishermen's Shacks: Negative Shapes as Focal Point, Sand Dunes: Granulating Washes, Forest Rapids: Wet-into-Wet Technique, Mountain Meadows: Palette Knife Technique, Trees: Idealized Design, Quiet Harbor: Contrast & Reflections, Daffodils: Backlighting

Index, 140 About the Author, 142

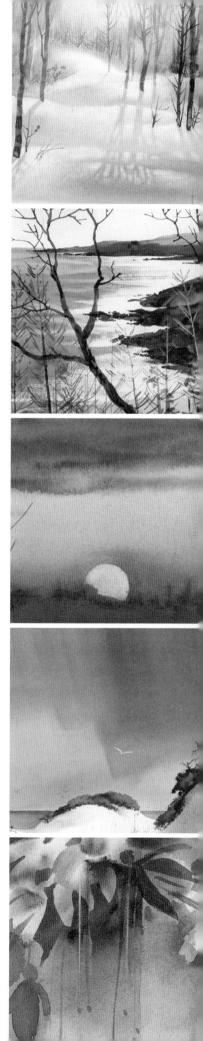

Introduction

It is my hope and desire that this book will help to further the technical advancement of young watercolor artists. I use the term "young" intentionally because age has nothing to do with experience or attitude. If you are a freshman watercolorist, you are young even if you happen to be a senior citizen.

In any endeavor, knowledge combined with experience and tenacity is the key to success. Knowledge about watercolor is readily attainable through study. Throughout the following pages I will show you how easy it is to paint watercolor after you have familiarized yourself with just a few techniques. This collection of techniques is based on solutions to problems that have confronted most of my students during my thirty years of teaching watercolor workshops.

Watercolor pigments

A common mystery to the vast majority of students is the nature of transparent watercolor pigments. In this book I include a chapter designed to shed light on the subject and dispel most of the confusion.

Design

Another area in which students are often lacking is a simple and basic knowledge of design. Unfortunately, this subject sounds very scientific, which translates into "no fun." This does not have to be true. In the chapter on composition and design, I explain some simple and easy-to-use principles that will creatively spark your design awareness.

Reflections

I find that many watercolorists paint water because they love this beautiful and intriguing subject. However, when it comes to painting reflections on the water, they get flustered and sometimes discouraged because they are not familiar with the physical laws of reflection. Even those artists who take license and paint a strongly abstracted design will paint a more convincing painting if the reflections feel right. To a representational artist, this knowledge is essential. My chapter on reflections comes to the rescue, should you need any help with this subject.

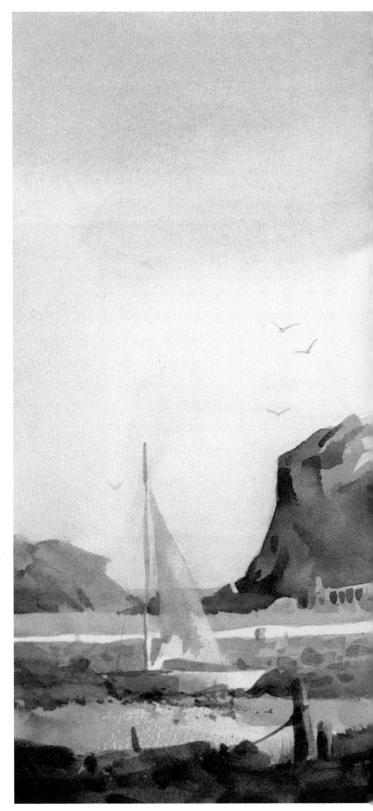

6

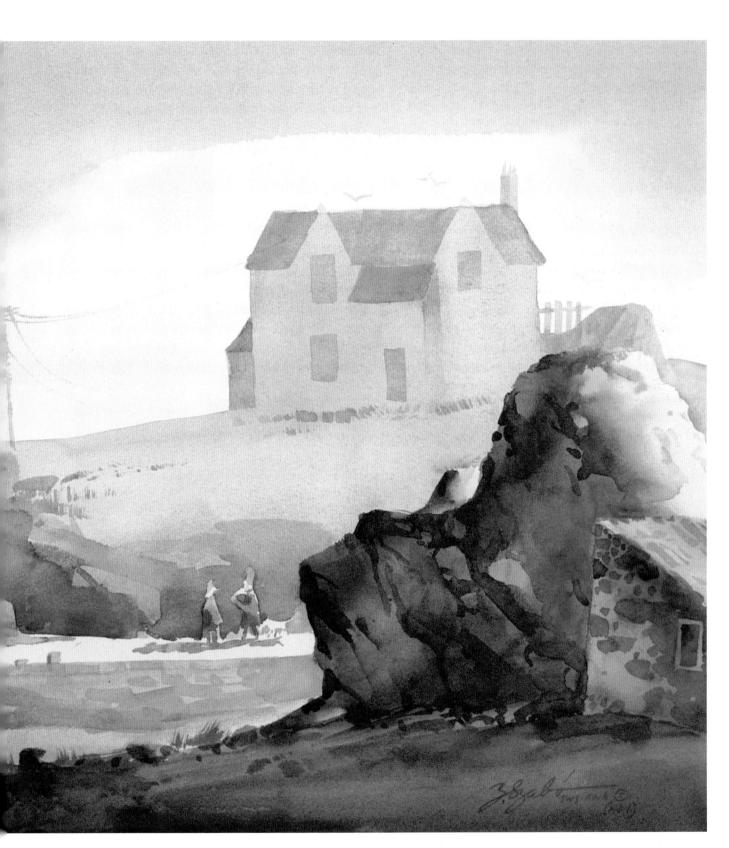

Low Tide 13½" × 17½" (34cm × 44cm) Collection of David and Bonnie Hauck

Popular Techniques

Because the technical behavior of watercolor is so varied, I have included many quick watercolor sketches to show you some of the most exciting and popular techniques that I use in my paintings. These examples, on pages 46 to 107, are not finished paintings but small informative sketches to explain particular technical points. You are free to copy them. They will also help you make sure that the tools you choose will behave well in your hands. In other words, I want you to master these techniques in the shortest possible time and enjoy the experience while you are learning.

Demonstrations

The last section in this book shows you many of the above principles and pointers applied in actual demonstration paintings. These paintings are shown in progress with step-by-step photographs of the works as they evolve.

I don't claim that everything you need to know about watercolor is in this or any other book. Watercolor is too fickle a medium to be explained so easily. However, I believe that, based on the material in this book, you can quickly reach a high level of technical efficiency. How far you will go with it will depend on your perseverance. Franz Liszt, the great composer and piano virtuoso, said "If I don't practice for one day I can tell the difference the next day. If I don't practice for two days my audience can also tell the difference." You don't have to take this literally to be a good watercolorist (unless you want to paint as well as Liszt played the piano). Few people paint every single day. Nevertheless, the more often you paint the easier it gets.

To make this book fun and easy to use, I am presenting the techniques in many short, illustrated sections to allow you to see what I'm talking about and to enable you to use this book either as a reference volume or a complete study guide.

Once you've gained the necessary skill, you'll be able to express your ideas and visions well enough to share them with the rest of humanity. Then you will invent your own new approaches to watercolor and virtually eliminate problems because you will be able to adjust and correct as you paint.

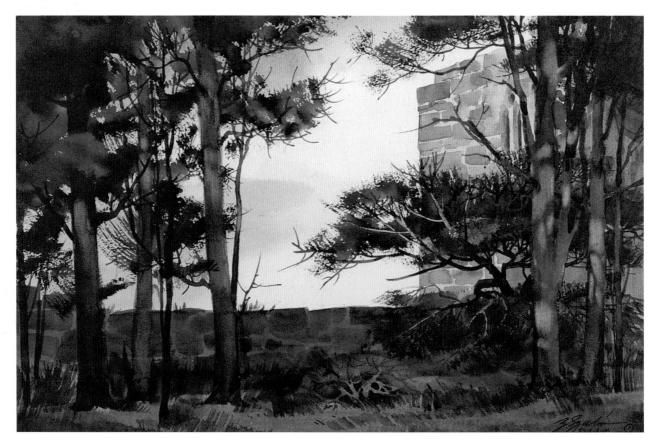

Light on History 13½" × 17½" (34cm × 44cm)

Oregon Harbor 11" × 14½" (28cm × 37cm)

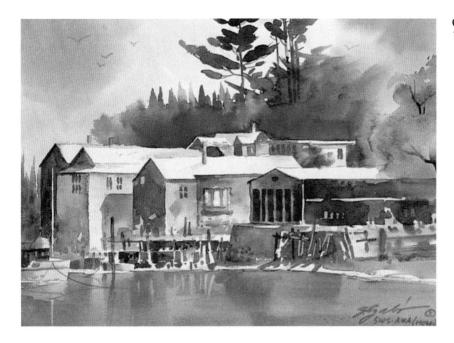

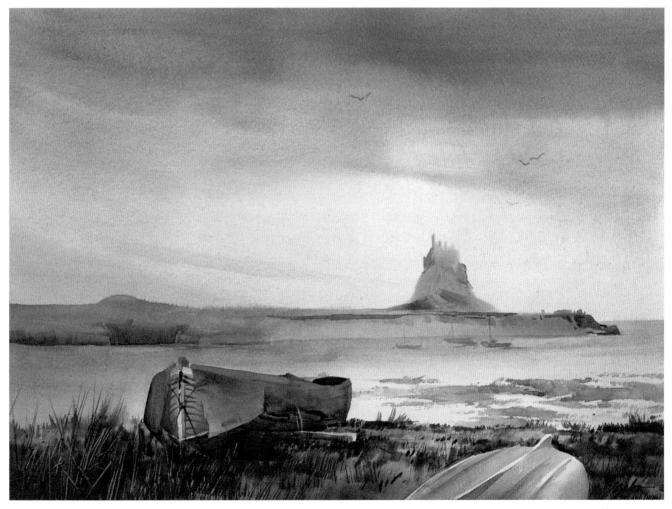

North Sea Bastion 13%" $\times 17\%$ " (34cm \times 44cm)

My Favorite Tools

Brushes

I have designed my own slant bristle brushes made from natural firm bristles in a variety of sizes [1" to 4" (25mm to 102mm)], and enjoy using them for rich dark colors. The soft slant brushes [1½" (38mm) and 2½" (64mm)] are also my own design and are most useful for delicate, light and wet washes. I also use a no. 3 rigger brush and a palette knife. As you probably noticed, all of these tools except the rigger are flat brushes. I prefer them because the corner can be used like a pointed round brush, whereas a round brush cannot make a wide stroke to imitate a flat brushstroke.

Papers

My favorite papers are 300-lb. (640gsm) coldpressed Lanaquarelle (French), 300-lb. (640gsm) cold-pressed Arches (French), and my newest treasured discovery is Noblesse (from Holland) made by Papierfabriek Shut Bv.

I use 300-lb. (640gsm) weights strictly for convenience, because heavy papers don't buckle like

thinner ones when they are wet. But heavy papers soak up more paint than the thin ones, so

2

В

you have to compensate for the loss of color by painting a little richer.

The makers of the Noblesse paper seem to have found the best solution. They have mounted a thin paper onto a heavy rag board so that the paper doesn't buckle. The mounting material between the paper and the board keeps the water from penetrating too deep into the board, so the colors stay very intense. The result is a flat, workable surface and a high degree of color survival.

Paints

Most of the time I use three brands of top quality transparent watercolors, though I've enjoyed painting with a few others as well—Lucas, DaVinci, Rowney and Holbein, just to name a few. My first choice is Maimeri, then Blockx, and of course, Winsor & Newton. All three are old, proven and reliable companies and their products are consistently of the highest quality. They honestly declare the permanency level of all colors in their literature. In the case of Maimeri and Blockx, all their colors are declared permanent. Winsor & Newton also calls most of their colors very permanent. However, because Winsor & Newton also serves the commercial art field (where permanent colors

as well as a few outright fugitive pigments. It's good practice to check the declared permanency level of any color of any brand before you fall in love with it. I will elaborate further on some of the idiosyncrasies of my favorite group of colors later.

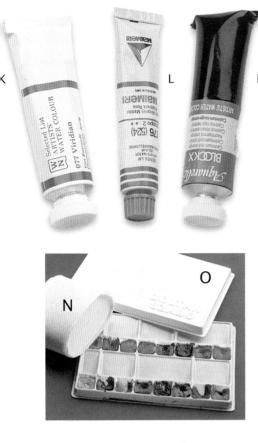

Palette and Brush Blotter

I use a plastic palette with a lid of my own design. I squeeze out my colors in advance and let them dry. Before I start painting, I moisten the colors and use them in the same consistency as if they were just freshly squeezed out of the tube. Because only a thin layer at the top is wet, I feel free to pollute one color with another while I paint and mix back and forth. To have lots of pure pigment available at any time, all I have to do is wipe off the thin contaminated layer from the top of the color and there is the clean paint waiting to be used.

MATERIALS

SLANT BRISTLE BRUSHES

- A 3" (76mm) Zoltan
- B 2" (51mm) Zoltan
- C 1" (25mm) Zoltan

SOFT SLANT BRUSHES

- D 21/2" (64mm) Zoltan
- E 11/2" (38mm) Zoltan

FLAT BRUSHES

G

- F 1½" (38mm) Zoltan Aqua Broad Flat
- G ¾" (19mm) Richeson 9100 Soft Flat

OTHER BRUSHES

- H #2 bright oil (China)
- I #3 rigger

PALETTE KNIFE J #814 Richeson

WATERCOLOR PAINTS

- K Winsor & Newton
- L Maimeri
- M Blockx

BRUSH BLOTTER

N Roll of toilet paper wrapped in Bounty paper towel

PALETTE WITH LID O Zoltan Szabo

I also make a moisture-controlling contraption out of a roll of toilet paper. I take out the center core, flatten the roll, and wrap a few sheets of lintfree paper towel on the outside (folded to the same width as the paper roll). I then tape its edge to stop it from unrolling. The toilet paper is very absorbent but it breaks down quickly when it is moistened, releasing tiny particles that can be carried onto the painting by the brushes. The wet-strength paper towel (Bounty) around the roll prevents this from happening. The absorbency is still there but the surface will not break down even in heavy use. Because the brushes usually absorb too much water when they are dipped into a bucket, I make a habit of touching my brush to the paper roll's surface before I dip into the color. Controlling moisture in the washes begins by controlling it in the brush.

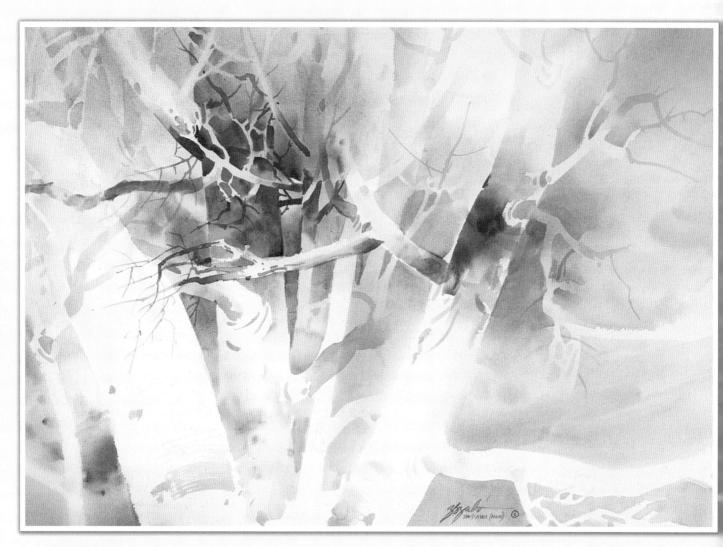

Emerald Tree 19" × 28" (48cm × 71cm) Collection of Gianni Maimeri

1

Qualities of Transparent Watercolor Pigments

rtists, being creatures of curiosity, will make changes in their palettes during a lifetime of painting, but whatever palette you start off with must be based on a thorough knowledge of each and every color.

Like most watercolorists, I spent several decades of my career using Winsor & Newton watercolors almost exclusively. But the popularity of these wonderful colors did not deter me from experimenting with other brands. I feel that I know the nature of most Winsor & Newton pigments, particularly those I kept on my palette, as intimately as anyone can. As the years went by, however, I found it more and more inconvenient to stubbornly stick with the same colors, particularly if they were not completely permanent. Even though the company is very good about declaring the level of permanence of their pigments, I decided to test some other major brands such as Grumbacher, Rowney, Lucas, Holbein, Da Vinci, Sennelier, Blockx and most recently, Maimeri. Winsor & Newton had a little edge over some of the other manufacturers until recently, but they all have some unique quality typical to each brand.

Because I refer to generic color names throughout this book, you would be wise to test your own favorite brands and colors to identify their peculiarities. Remember that the nature of colors—even if they are called by the same name—may vary from one brand to another.

On the following pages are samples of watercolor paints that I've categorized by some important characteristics, such as transparency and opacity, staining and nonstaining, reflective and sedimentary, etc. But be aware that some of the colors' behavior will vary from one brand of paper to another. Expect consistency of paint behavior only on good quality, all-rag paper.

Transparent Colors

These wonderful, glowing, luminous colors that all watercolorists love behave similarly to stained glass. They let light penetrate through the wash and reflect from the paper through the color. These are the most suitable colors for glazing (applying a wet wash over a completely dry wash without disturbing the lower layer) because they don't build up when they overlap. These true transparent colors make the most glowing, clear darks, but some of these pigments are very strong and tend to dominate when they are mixed with other colors.

If you want to use only true transparent colors, you could use liquid watercolors. Unfortunately, most of the watercolors in liquid form are not very permanent, so you need to research their light fastness. However, even if you find a permanent liquid watercolor brand, you'd still rob yourself of the opportunity to use the excitingly varied nature of your pigments. My advice is to use an artist's quality transparent watercolor in the tube made by a reputable company.

Transparent Colors Include:

- Phthalo Violet
- Phthalo Blue
- Phthalo Green
- Scarlet Lake
- Rose Madder
- New Gamboge
- Hooker's Green
- HOOKEI S GIEEI
- Cyanine BlueIndian Yellow
- Permanent Rose Permanent Rose Phtalo Green

Testing Transparency

To test the transparency level of a color, draw a ¼" (6mm) thick line with a black waterproof marker or with India ink. Over this line, place a brushstroke of the desired color in medium dark consistency. Transparent colors will not show at all where they cross over the black line because the black absorbs all the light.

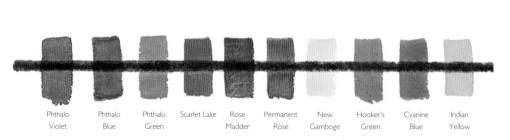

Opaque Colors

Though all watercolors called transparent are luminous in thin washes, some have more body than others. These opaque or body colors are capable of covering other dry washes when they are applied in a thick consistency, even if the dry underwash is dark and the top color is light. They are not truly opaque, as acrylics are, but are more so than the transparent colors.

Opaque Colors Include:

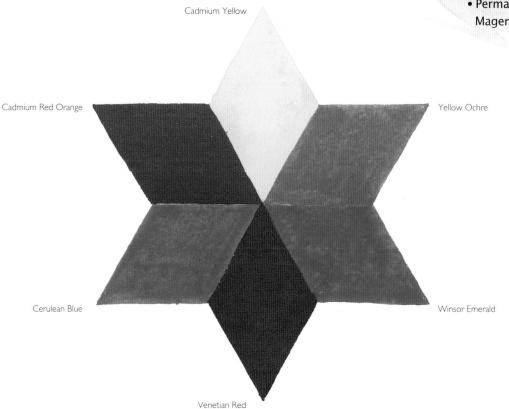

Testing Opacity

To test the degree of opacity in a color, first draw a ¼" (6mm) wide line with a black waterproof marker or India ink. Over this line, place a medium dark brushstroke of the desired color. To whatever degree the color covers up the black line, that's how opaque the color is.

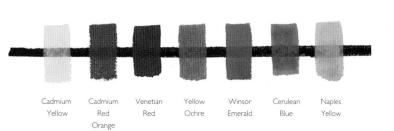

Reflective Colors

Reflective colors behave the opposite way of the true transparent pigments. The most transparent colors act like stained glass. They let the light penetrate through the wash and reflect from the paper through the color. Reflective colors let a certain amount of light get through to the surface of the white paper, but they are also capable of reflecting light from the surface of the paint.

If painted over a waterproof black line, reflective colors look very transparent while wet, but show a little of their own hue after they dry. Opaque, semiopaque and reflective colors don't glaze well because they build up to a thick layer. All opaque colors that are light in hue are reflective, but not all reflective colors are opaque. A few reflective colors are considered transparent, yet they reflect light when they are applied in heavy consistency.

Reflective Colors Include:

- Cobalt Violet
- Cobalt Blue
- Raw Sienna
- Raw Umber
- Viridian Green
- Aureolin Yellow
- Magenta
- Cobalt Green

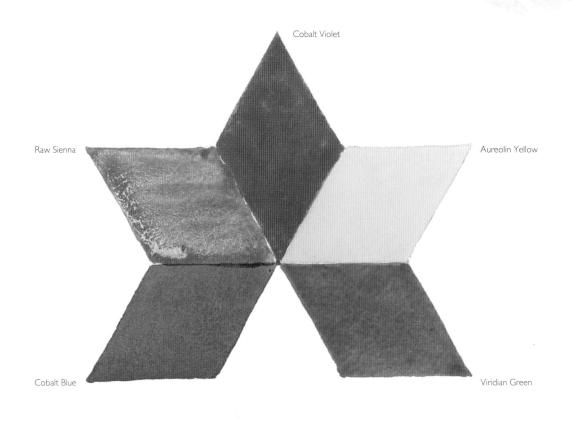

opaque colors.

Sedimentary Colors

Sedimentary, or granulating, colors are made from physically heavy pigments. Because of their weight, sedimentary colors sink into the water like pebbles. On rough or cold-pressed paper, they are first to land in the low, hollow spots on the paper. On the smooth surface of hot-pressed paper, they settle quickly, but water rivulets create little river-like separations. All this behavior translates graphically into texture. A sandpaper-like grain is the nature of these pigments. When you mix them in a wet wash with other colors, they will look grainy and may separate, while transparent colors will dissolve in water like tea and stay active as long as the wash is wet. When sedimentary and non-sedimentary colors are mixed, each color is individually visible, for example, Manganese Blue and Burnt Sienna, and Raw Sienna and Phthalo Blue.

Sedimentary Colors Include:

- Ultramarine Blue
- Raw Sienna
- Sepia
- Cobalt Violet
- Viridian Green
- Manganese Blue

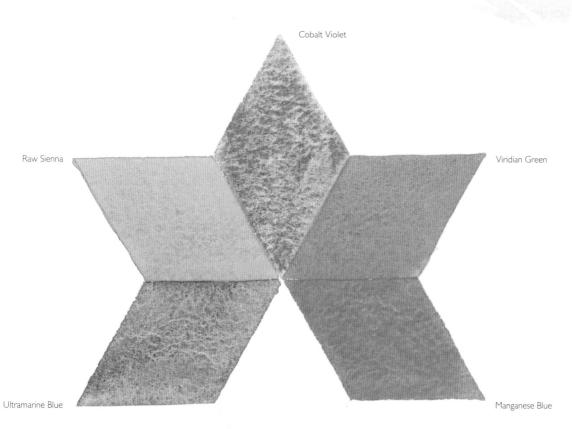

No Testing Necessary There's no need to test sedimentary colors. Their grainy texture is easy to see, particularly if the color is applied with lots of water in the brush.

Staining Colors

Dark Staining

When a pigment tints the fiber of the paper it is called a staining color. These colors behave like a dye. The staining nature in a pigment is not relevant to other qualities. Opaque, sedimentary or transparent colors can be either staining or nonstaining. The degree of staining quality of a pigment is important to know only if you intend to lift out a color. A staining color will show a tint of its hue even after you have tried to wetscrub and blot off the paint. This behavior remains even if the staining color is mixed with other nonstaining colors.

Light Staining

These few pigments stain a little if they are applied with heavy pressure or with a scrubbing technique. However, their hue retains only a light tint in the paper. If they are mixed with other nonstaining or light staining colors, the resulting mix will stain according to the strength of the dominant color.

Dark Staining Colors Include:

- All phthalo colors
- Burnt Sienna
- Scarlet Lake
- Sap Green
- Hooker's Green

Light Staining Colors Include:

- Gold Ochre
- Cobalt Blue
- Gamboge Yellow
- Cerulean Blue
- Magenta

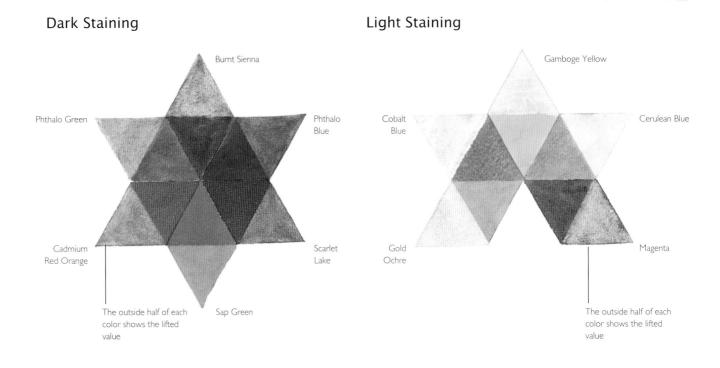

Testing Staining Strength

To test the staining strength of a color, paint a rich brushstroke and let it dry. After loosening the pigment with a very wet brush (such as a small oil painting brush), blot it off with a tissue. A staining color will get a little lighter but will leave a strong impression of its hue in the fiber of the paper. It's important to test on the same kind of paper as you will use for your painting. The staining quality of a color may vary from one brand of paper to another.

Nonstaining Colors

These colors cannot stain at all. They are ideally suited for lifting because on some papers (Arches, for example), you can recover pure white paper if you remove the wet or dry colors by scrubbing with a wet brush. On some papers, a slight residue will remain that shows against white paper, but will look white when surrounded with darker painted shapes. These colors do not penetrate the fiber of the paper, but just sit on top of it, held in place only by the sticking strength of the binding agent in the paint.

Nonstaining Colors Include:

- Emerald Green
- Permanent Rose
- Manganese Blue
- Aureolin Yellow
- Cobalt Violet

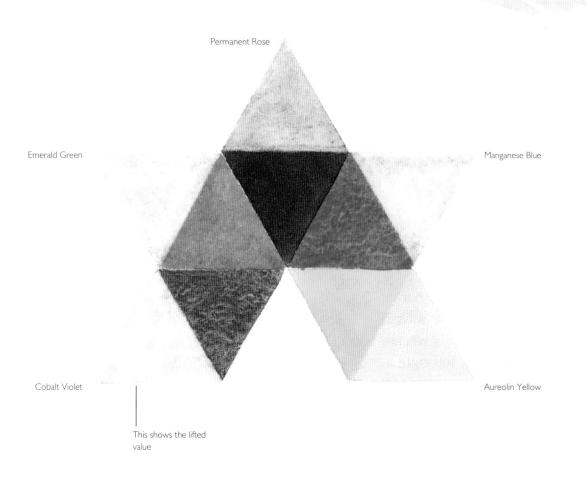

Testing Nonstaining Colors

Test a nonstaining color by painting a brushstroke in a medium-dark value and letting it dry. With a well-moistened scrubbing brush, loosen the color and blot it off with a tissue. A nonstaining color will come off completely and white paper will be recovered. Because paper brands react differently, test with the same kind of paper as you will use for your painting. This color star was painted on 140 lb. (300gsm) Waterford cold-pressed paper.

Dominance

Pay extra attention to this most often overlooked color peculiarity. Color dominance needs to be considered when more than one color is mixed into a wash. The same color combination may result in an almost infinite variety of colors depending on the proportions of the mix. Whichever pigment is the most dominant in the mix will impose its characteristics on the wash, not only in the hue but in all other aspects of its nature as well, such as staining or nonstaining, opaque or transparent.

If the dominant color is Manganese Blue (a sedimentary pigment) and the secondary color is Burnt Sienna (a transparent color), the mixed color will not only be a bluer hue but will also be a grainy-textured color and will lift off better than Burnt Sienna would lift by itself. This is because Manganese Blue is the dominant color and not only its hue but also its other natural characteristics impose their dominance over the other color.

If you intend to dominate a wash with a gentle color (Permanent Rose) and use a basically strong color (Phthalo Green) as a weaker complement, as in the example, you must increase the amount of the dominant color (Permanent Rose) in the mix and substantially reduce the quantity of the secondary pigment (Phthalo Green). When the dominant color is strong (Phthalo Green) and the secondary is moderate (Permanent Rose), naturally the quantity of the colors in the mix reverses.

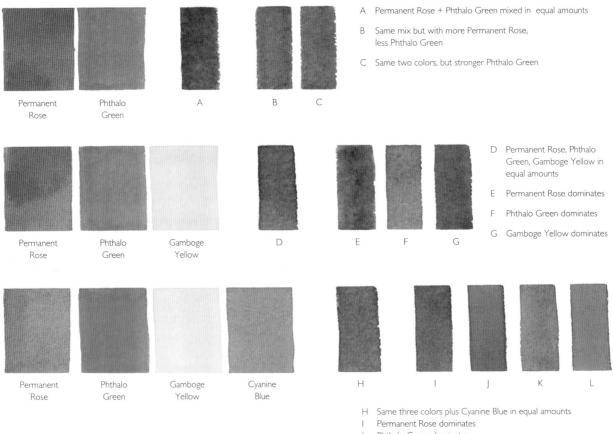

J Phthalo Green dominates

- K Gamboge Yellow dominates
- L Cyanine Blue dominates

Staining Dominance

Whenever you use a staining color by itself, it tints the fibers of the paper and cannot be removed completely. When staining colors are mixed with other weaker hues (but are still dominant in the mix), they can still leave their hue in the paper, though to a lesser extent.

The most obvious influence of staining dominance shows up when you try to lift the color after it has dried. Whichever staining color touches the paper will dominate the lifted color, regardless of what other colors may be glazed on top of it. If the staining colors are applied together in one wash, the lifted color will favor the dominant hue. If neither dominates, the combined color will appear in a lighter value. Here I used two very strong staining colors, Alizarin Crimson and Phthalo Green.

Below the two colors, I painted a color bar with Alizarin Crimson and let it dry, leaving a little of it showing. I glazed an estimated equal value of Phthalo Green on top of it and again allowed it to dry. Finally, I made a dark wash of equal amounts of both colors.

Next, I did the same thing but in reverse order, with Phthalo Green first, then Alizarin Crimson on top.

After letting them dry, I rinsed loose as much of the combined colors as I could with a small soft brush loaded with water, and blotted it off with a paper tissue. The soft lifted area ended up light gray on the lower color bar, pink on the first color bar and green on the second.

Alizarin Crimson

Phthalo Green

Alizarin Crimson painted first, with Phthalo Green glazed on top

Phthalo Green painted first, with Alizarin Crimson glazed on top

A mix of equal amounts of Alizarin Crimson and Phthalo Green

Palettes

Maimeri watercolors now make up my own personal palette; they replace the older Artisti colors. The paintings in this book were done with Artisti colors. The new Maimeri colors are even more intense than the Artisti line was, and they seem to hold their chroma very well after drying. Some of the colors have been changed or discontinued, so new pigments have been substituted in where necessary. I lay them out on my palette in an order similar to the spectrum.

My next two favorite palettes are made up of Blockx watercolors and Winsor & Newton. I selected these palettes based on my own personal needs. Though they are not duplicates, they are as close as their nature permits them to be, considering the differences between the two brands. You might say these are my two interchangeable duplicate palettes. They include colors that are essential for my special techniques, such as Winsor & Newton Sepia, either brand's Manganese, Blockx Magenta and Blockx Green.

My Maimeri palette (Italian extremely permanent colors):

Raw

Sienna

Burnt Sienna

Yellow

(Lemon)

Permanent Yellow Deep

Orange Lake

Crimson Lake (Rose Madder)

Permanent Green Cupric Green Light (originally Deep (Phthalo Cadmium Green)

Primary Red Magenta

Turquoise Green

(Phthalo Blue)

Verzino Violet

Bluish (Violet

Lake)

Ultramarine Deep

Cobalt Blue Light

Primary Blue - Cyan

My Blockx palette (Belgian extremely permanent colors):

Burnt

Sienna

Light

Rose Lake

Magenta

Van Dyck

Brown

Turquoise Blue

Cobalt

Violet

Cobalt

Blue

Green

Blockx Green

(Phthalo)

Blue

Ultramarine

Blue Deep

Cerulean Blue

My Winsor & Newton palette (British permanent colors):

Burnt

Sienna

Scarlet

Lake

Red Orange

New Gamboge

Antwerp

French

Ultramarine

Manganese Blue Hue

Aureolin Yellow

Raw Sienna

Cobalt Violet

Sepia

Winsor Blue (Red Shade)

Cerulean Blue

Viridian Green

Winsor

Green (Yellow

Shade)

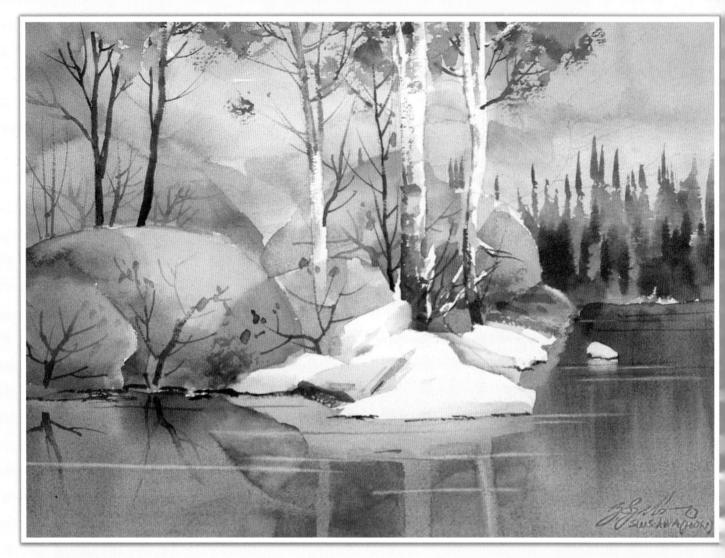

Pearly Whites 11" × 14½" (28cm × 37cm)

2

The Rules of Reflection

I may surprise you that even some well-established artists do not know much about the rules of reflection. Throughout my years of teaching I have found reflections to be extremely troublesome to my students, in spite of the fact that water is one of their favorite subjects. Rules sound so serious and scientific. The creative mind wants to turn them off or go into avoidance mode, but this robs the artist of the rewards of success.

On the following pages, you will see how easy it is to understand the rules of reflection. I have included not only small painted illustrations but also a lot of untouched photographs. I hope that the camera will convince even the most determined doubting Thomas. Now let's look at some rules of reflection depicted by the most common reflective surface: water.

Characteristics of Waves

Moving water can be broken down into components: waves. Moving waves are difficult to study, but a photograph will show them in detail. Waves have near and far sides. The near sides of the waves appear wide and they are slanted on a steep angle. Because they tilt slightly away from you, they often reflect the high sky combined with the water's local color. The local color affects the hue of the wave's near side because the steep angle allows you to look partly into the body of the wave.

The wave's far side appears narrower because of perspective's foreshortening effect. The angle of incidence and the angle of reflection are low as they bounce off the wave's far side. Consequently it will reflect the low, distant sky and whatever else is in the visual path of the angle of reflection. Because of the severe tilt, it displays only reflection and does not show any local color.

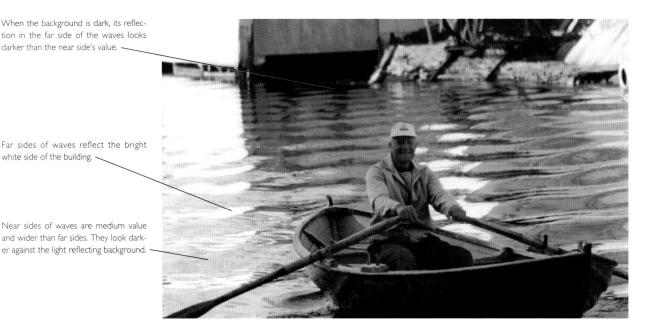

See how the characteristics of waves affect reflections in rules 8, 9 and 10.

Perfect and Imperfect Color Reflectors

Reflecting surfaces may be broken down into two categories: perfect and imperfect reflectors. There are no exceptions. Perfect reflecting surfaces do not have local color of their own; imperfect ones do. For our purposes, a mirror is a perfect reflector but water is not.

A Reflector's Local Color

To identify the local color of a translucent liquid with a reflective surface, such as water, you must first eliminate the reflection. Let's take a hypothetical situation. You are in a boat on a lake. If you lean over the edge, where your head blocks out the sky's reflection, the local color appears. This is the water's local color (without reflection). If the water is very shallow, its bottom will show through as the local color. In the case of a large body of water, the mass volume of the water combined with all its minerals and microscopic life composes the local color.

Any given point on an object must reflect directly below itself.

This rule is true whether the object stands straight or leans to the side. For example, if an object stands upright its reflection will continue straight down. If an object leans to the left, its reflection will also lean to the left so that all points on it, including its far tip, will reflect directly below themselves. If the object leans to the right, its reflection will also tilt to the right.

The palm trees reflecting in the still water stand at a near-perfect vertical, therefore the reflection of each tree continues straight down from the trunk. The reflection of the leafy top is directly below the leafy top of the tree itself. The distance from the bottom of the tree to the top in the reflection is exactly equal to the height of the real tree, even though part of the trunk is not visible in the reflection.

Each point on each branch reflects exactly below itself.

Try to pair up a spot on the center branch with its reflection. Pinpoint the bend in the branch. Directly below it you'll find the reflection bending at the same angle.

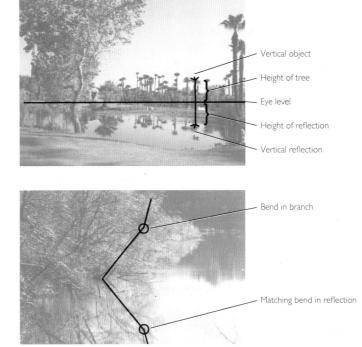

In this painting, the puddle of water is the only reflective surface. If the puddle reached all the way to the tree, it would reflect the tree from the roots up. But the puddle is located so that only a portion of the trunk is reflected.

To determine what part of an object would reflect in a puddle, use this simple trick. Trace the object on tracing paper. Turn the tracing paper over just below the object. On your painting, trace the portion of the object that falls on the puddle. Reflected portion

Left- or right-tilting reflections appear in exactly the same angle as their corresponding objects and cannot be shorter or longer. They must be the same length so that the far tip of the object reflects below itself.

An object tilting toward you will foreshorten and will seem shorter than its reflection.

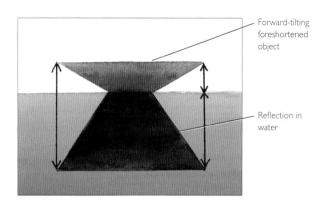

The top (Magenta) portion of this illustration leans toward you and is severely foreshortened. The black shape represents its reflection in the green water and appears longer than the tilted object. The more severe the tilt, the greater the difference.

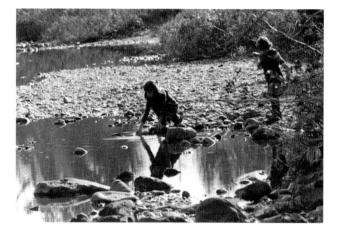

In this photo, the height of the child leaning toward the viewer is shorter than her reflection in the water.

RULE 3

When an object tilts away from you, its reflection becomes shorter than the object itself.

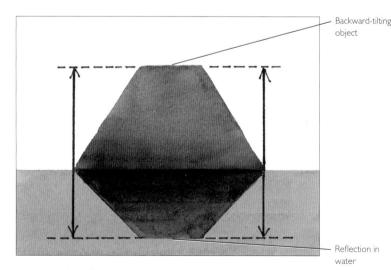

Imagine that the magenta shape is leaning away from you. Because of perspective, the reflection (black) will appear foreshortened. The situation is exactly the reverse of the diagram in rule 2.

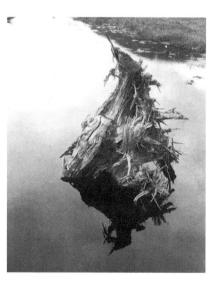

Because this tree stump is leaning away from the viewer, its reflection appears shorter.

The reflection of an object appears the way you would see it if your eyes were on the surface of the water where the reflection is located.

Your vantage point is always higher than the reflection on the water's surface. This is the reason why you may see the inside of a small boat on the water, but its reflection will show only the outside of the boat's hull. The underside of an object leaning toward you, such as a branch, may not be visible from your vantage point, but its *reflection* will show the underside because it is presented to the reflecting surface on the water.

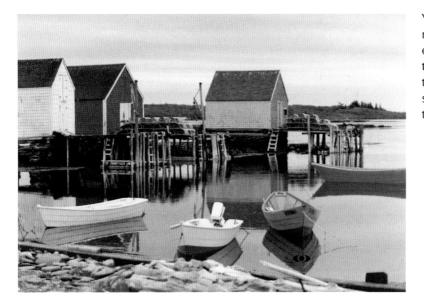

You can see inside the boats but the reflections show only their hulls. If your eyes were on the water where the reflections are, you would see exactly what the reflections show. Viewed from the surface of the water, the hulls would hide the boats' interiors.

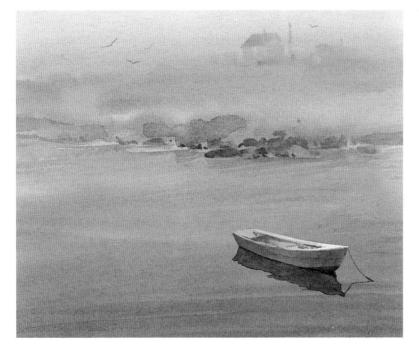

This watercolor illustrates the rule we see in the photograph above. The reflection shows only the boat's hull, not the interior details.

The tonal value of a reflection is controlled by the deepest value of the water's local color.

No reflection can be darker than the water's local color, regardless of how dark the originating object may be.

- If the value of the reflecting object is lighter than the deepest value of the water's local color, they will combine and the reflection will be darker than the object.
- If the object has the same value as the local color of the water, its reflection will also have the same value.
- If the object is darker than the water's local color, it still reflects the same as the local color.
- In milky water, the deepest value of the local color is relatively light.

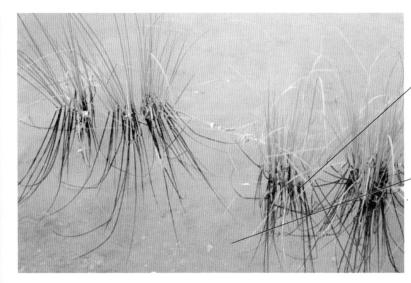

Reflection of weeds blocks out the sky and shows true value of local color

Color and value of reflected sky and muddy bottom combined

Here, the color of most of the water's surface is a combination of the shallow bottom (local color) and the sky's reflection. The fresh green weeds' color is very close to this gray value. Where the weeds block out the sky's reflection, the dark muddy bottom dominates the color and value of the weeds' reflections.

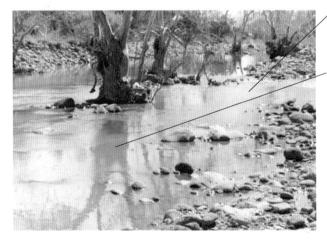

The bottom of the shallow creek (the local color) in this photo is light. Consequently, the reflection of the dark tree is lighter than the tree trunk itself. Sky's reflection plus mud combined

Sky's reflection is blocked out by the tree trunk. Reflection shows only the deepest value of the local color

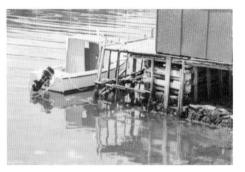

As the tide came in, it churned up the particles in the water and made the water milky, causing the dark shapes to reflect lighter than their own value. In fact, they reflect exactly the same value as the deepest value of the water's local color, a mid-tone gray.

The color of a reflection is influenced by the local color of the water.

A white boat will reflect a little darker than its own value but in the same color as the water itself. The reflection of a neutral color will be dominated by the local color of the water. Bright colored objects combine their color with that of the water. For example, orange color in gray water will reflect as a grayed orange.

Blue boat reflects darker blue-gray 🔨

Whites reflect darker than their own value and show the local color of the water (blue-gray)

Orange pole reflects grayer because it adds the water's local color to its own -

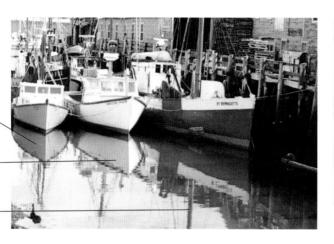

The colors of the reflections show the objects' own colors combined with the water's local color (blue-gray). Notice how the white hull reflects darker than its own value and shows a blue-gray color. This identifies the water's hue. Because still water resembles glass, water reflections may be initiated on a sheet of glass for study purposes. You can place white, black or colored paper under the glass to change its local color as well as its reflective quality.

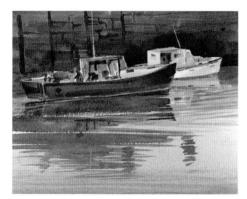

The blue gray water in this painting makes the yellow-green boat (as well as the white one) reflect bluer. The orange raincoat shows its own color combined with the water's hue. Reflections of neutral colors are dominated by the water's local color

The red boat reflects red plus the water's local color (greenish brown), resulting in a reddish brown. All the other colors are neutral enough that their reflections are totally dominated by the brownish local color of the water.

The angle of incidence and the angle of reflection are always the same and they are inseparable.

This rule is very important because it determines what objects reflect where and why. It can be very useful to you, especially when painting in the studio, to figure out the correct placement of a reflection.

Though still true, it is more difficult to see this rule in action on moving water. The movement of waves makes it difficult to concentrate on the reflection. In addition, because the reflecting surface of a wave is not horizontal like still water, its slant can cause some confusion. The angle of incidence and the angle of reflection relate to a tilted surface, not to a flat surface.

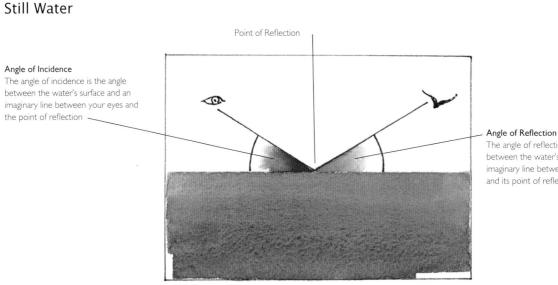

The angle of reflection is the angle between the water's surface and an imaginary line between the actual object and its point of reflection

Wavy Water

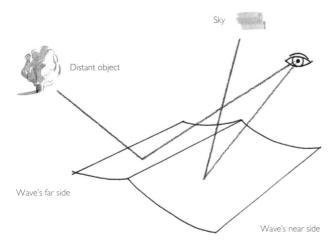

When there are waves present, the angle of reflection bounces off a tilted surface rather than a flat one. As you can see, the angle is different on the far side of the wave than on the near side. This causes the eye to see a different image in each side of the wave.

To help you understand this rule as it applies to waves, experiment with a small hand mirror. When the mirror lies flat on the table it reflects one view. If you pick up one edge of the mirror so that it is at an angle to the table, it will reflect a different view.

Reflections are not in the water but on its surface.

When a reflection stretches across and reaches the water near you, it follows the movement of the nearby ripples. An image reflecting on moving water will wiggle on the dancing waves. Waves have perspective like railroad ties. Wiggly waves close to the reflecting object will appear smaller than those close to you because of perspective. Also, the reflection of the far tip of the object in the nearby waves will start to skip just before it stops reflecting on the waves' near sides. For a short space it keeps reflecting only on their far side.

The reason is that the high angles of reflection bounding off the near sides of the waves will be the first to pass over the top of the image and stop reflecting it. However, from the far sides of the same waves, the angles of reflection still meet the object and must reflect. Their angles of reflection are low enough to allow the top of the image to reflect a little longer than it does on the near sides.

The trees are too far away to reflect in the foreground water

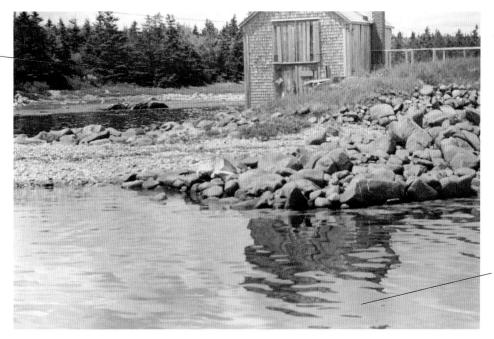

The near sides of these same closeby waves reflect only the sky.

This old fishing hut is reflecting into very wavy water. You can study how the top of the building doesn't show in the near side of the closer waves while it still shows its reflection in the far side.

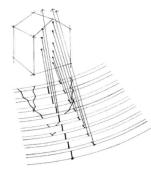

Note how many more angles of reflection hit the building from the flatter far sides of the waves than from the steeper near sides.

If a gentle wind blows from the side making many tiny waves, you may see breeze patterns on the water's surface.

These light zigzagging shapes often interrupt an otherwise perfectly calm reflection. They are dominated by the color and value of the sky. Because these shapes have a habit of disappearing, you need to freeze them in your mind and design their shapes to suit your composition.

Calm Water

In this photo, I managed to freeze the dancing action of the breeze as it was breaking up the motionless surface. The blue color is the reflection of the sky. The light value of the sky supplied a very pleasant contrast to the sandbars in front.

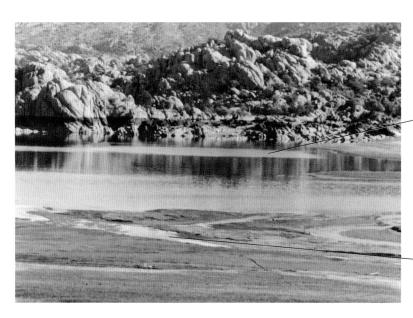

This breeze shape, reflecting the color of the sky, looks confusing at this location. I would leave it out of my painting.

This useful breeze shape sets off the sandbars.

Choppy Water When a stronger wind causes the water to be choppy, the sideways rolling, choppy waves reflect only the sky color. The objects above the water, such as the boat, do not reflect.

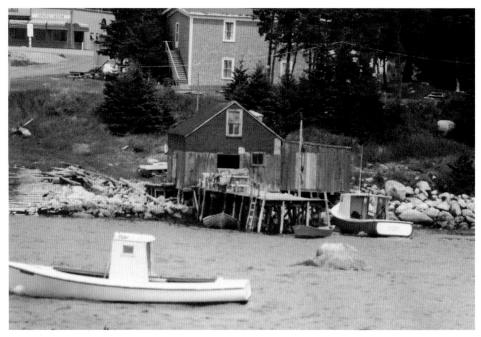

When a very light subject against a very dark background reflects in gently moving water, its reflection may appear much longer than the length of the object itself.

The brighter the image and darker the background, the higher the contrast will be. Higher contrast causes the reflection to stretch farther. The highest contrast and longest reflection possible usually is caused by the light source itself (low sun, moon, electric light at night, etc.). This reflection phenomenon is caused by the fact that the water's local color is very dark. The dark secondary light source (e.g., a late sky) cannot illuminate the particles in the water that form the water's local color. (During daylight the whole sky releases light and brightens the body of water.) The delicately moving waves pick up the only bright reflection on varying spots of their shiny surface without any competition from neighboring mid-values. However, the light reflection will lose value as it travels farther from its origin and closer to you. The farther the reflection is located from the subject, the more the local color absorbs its value until it consumes it.

If there are some very dim mid-values surrounding the bright object, the length of the reflection will be moderately long. However, if the background is black, the reflection may reach the near edge of the visible surface of the water.

If the water is not moving, the reflecting bright object will be the same size as it appears in reality even if the subject is a highcontrast light source. The bright sun reflects only on the far Ti sides of the waves and continues to the bottom of the photo.

The brightest object is the light source.

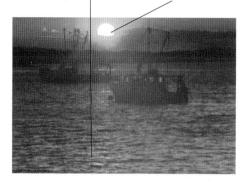

The sun, the light source on this photo, shows an extremely high contrast. Even though the water is very choppy, its reflection dances all the way down to the closest waves.

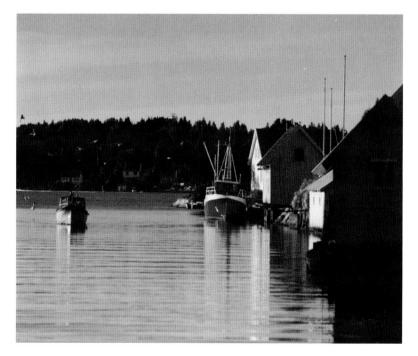

The red boat and white walls of the buildings that face the setting sun are brightly lit. The contrasting values of the lightest and darkest shapes stretch down to the bottom of the photograph, farther than the actual height of the shapes.

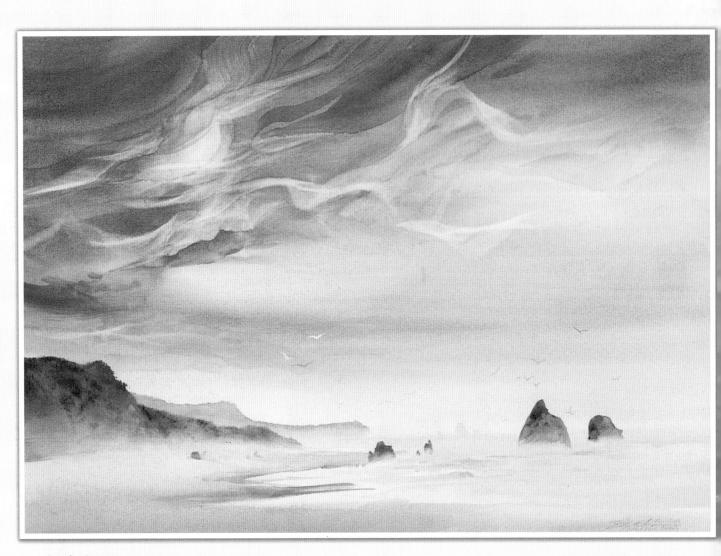

Smoke Storm 19" × 28" (48cm × 71cm) Collection of Willa McNeill

3

Composition and Design

Painting is a visual art. Composing a painting means that the artist must use visual means to express ideas and communicate emotion. All paintings are the result of composed graphic elements. They may be good, bad or indifferent, but how they communicate depends on the artist. Stimulating organization makes a painting pleasing to the eye. A balanced composition doesn't mean computer-like perfection, but rather a comfortable harmony between all elements for the benefit of the whole.

Paintings that are only technically perfect seem stiff and sterile because they do not stimulate emotions. People do not respond to art with skilled reason, but with immediate and honest gut reactions. An artist needs to know how to deliver graphic symbols that can communicate emotional qualities. It's helpful to understand these symbols and the part they play in compositional reasoning when we plan our paintings.

Carefully planned elements are every bit as good as accidently derived ones. The talent involved in using happy accidents lies in the decision to keep or reject them.

The Illusion of Space

A good painting is a successful illusion indicating more than a flat, two-dimensional surface. The job of an artist is to achieve a desired new reality including the possible illusion of three dimensions.

The first step is to choose the size and proportions of the watercolor paper. This is called the support shape because it will support all the details of the painting. This two-dimensional shape represents potential three-dimensional space hosting elements that have depth in reality. The illusion of depth in the painting must be convincing enough to trick our eyes into seeing three dimensions.

Distant objects appear smaller and less defined Distant objects take on a blue tone.

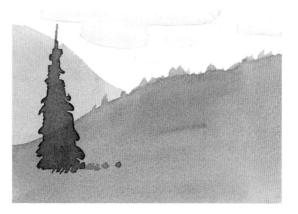

Overlapping objects add depth

When a shape overlaps another, it will appear to be in front of the one it partly covers. The way children and primitive artists like to place distant elements above closer ones is an instinctive attempt to imply the illusion of depth.

Real objects relate to each other in scale Shapes representing them in a painting need to be in relative scale as well. For example, a tree can't be taller than the mountain it stands on; a rider can't be bigger than his horse; a handgun can't be as big as the man who holds it. Scale is played with in cartoons and caricatures.

Warm colors advance while cool hues recede Perspective allows the shapes within a painting to appear as if they were located in three-dimensional space. Color perspective allows objects to appear as if they exist in an atmosphere that has depth.

Graphic Symbols

Graphic symbols are painted components intended to resemble something familiar to the conscious mind, but that may also have another meaning to the subconscious intellect. For example, the shape of a spruce tree not only looks like an evergreen, it also serves as a pointing arrow directing the viewer's attention away from itself. An orange oval is a colorful shape that may be read as the symbol of an autumn leaf.

Directionals Wedge shapes point like arrows.

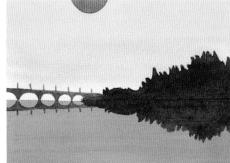

Leading the Eye Curves, straight lines and repeating elements lead the eyes as well.

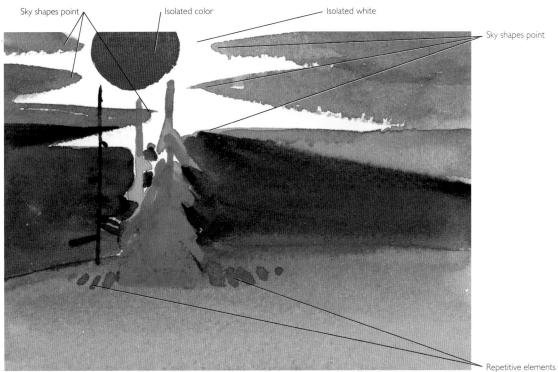

Repetitive elements point

Too Many Pointers

If the viewer's attention lingers in one spot, maybe too many "pointers" aim at that point. If that spot is on the edge of the painting, the viewer's eyes may leave the composition.

Path of Vision

The human eye is incapable of reporting visual images to the brain fast enough to comprehend everything on a painting at one glance. The eyes have to roam through the surface from one area to another. This visual travel pattern is called the path of vision. It can be instinctive or directed. In a well-composed painting, the path of vision may be determined by skillfully arranged graphic symbols. The viewer's path of vision responds instinctively to the artist's directed signals.

The directed path of vision must be a subtle suggestion, not a roaring command. The viewer must be gently guided, not shoved through the painting by brute force.

Isolated Elements

The viewer's first attention is directed to any isolated element, particularly in a bright color or to a spot with high contrast. This attraction becomes even stronger if both conditions exist in the same location. If several of these places are present in equal strength, the eyes will often select the lowest one first.

Overall Patterns

When the composition consists of pattern-like, equally important and evenly distributed elements, the path of vision usually begins at the bottom center.

The Corkscrew Path

The ideal path of vision works as a corkscrew moving in a circular motion toward infinity while touching all four sides and bypassing all four corners. The Western viewer's eyes will usually move clockwise (left to right) because we read that way and our habits influence our behavior.

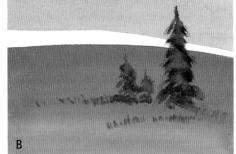

Edges

An undisturbed line across the painting is an obstacle to a comfortable path of vision in painting A. An edge placed in this manner needs to be interrupted by graphic stoppers such as a crossing shape (B) or a varied edge (C). The visual journey, the corkscrew-like movement that I referred to earlier is also a psychological journey for the viewer. Directing that journey is one way to communicate your feelings. But it is impossible to flawlessly predict the entire path of vision. It has to grow with the composition little by little as the painting progresses to its completion.

Path to the Distance

This visual journey extends not only up and down and sideways, but into the illusionary distance as well. In a realistic painting with depth, the artist must lead the viewer's eye in three dimensions.

Planes

White paper serves as a background for watercolor. It is flat and has only width and height, but after staring at it for a while, an illusion of depth will appear to the mind's eye. The artist can actually feel like the square space has planes foreground, middle ground and background.

If a line is drawn across the paper, and the viewer concentrates on it for a while, the line will appear to be an edge where two planes meet. At first, both planes will look flat, but after a little more staring, they will appear to be on a three-dimensional tilt bending away from or toward the viewer. The line between the two planes will advance or recede.

When these few hints are applied, they can cause an exciting interaction between the suggested planes. Representational details should enhance, not distract from this relationship.

Balance is the key to good composition. Any elements with overpowering visual attraction will disturb unless they are balanced with complements. Well-balanced elements will induce an exciting play of tension in the painting. Lack of balance creates tension, causing the viewer to leave the composition.

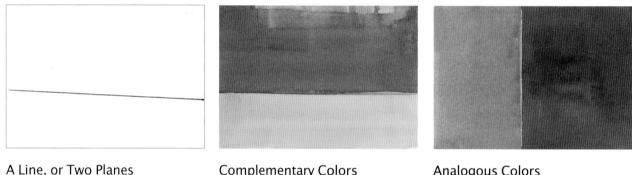

A Line, or Two Planes A line drawn across a white sheet of paper will take on the appearance of the division between two planes, perhaps sky and earth. Complementary Colors Flat washes of strongly contrasting (complementary) colors on the two planes will make the planes vibrate and create tension.

Analogous Colors Two flat rectangles in similar value occupied by analogous (related) colors feel quiet and agreeable.

Balance When they severely taper toward one another, they support (balance) each other.

Active Imbalance If they taper away from each other, an active imbalance occurs, similar to a tug-of-war.

Shaded Planes If planes are shaded until they seem to taper in each other's direction, subtle tension is created.

Parallel Planes When both tilt in the same direction (parallel planes), both appear to be slipping away.

Narrow Horizontal Planes If the same narrow planes are placed horizontally, they feel comfortably stable and calming.

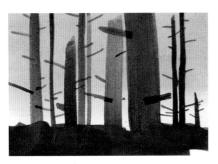

Narrow Vertical Planes Narrow vertical planes close together resist each other, creating independent strength for each.

Similar Values The eyes travel more easily from shape to shape when the shapes are close in value and color.

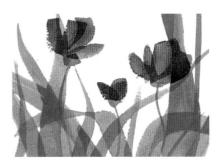

Illusion of Movement Overlapping transparent shapes create the illusion of movement.

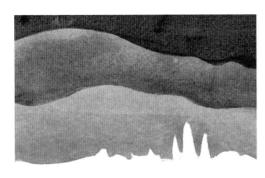

Planes Have Different Values and Color Temperatures

Generally, dark tones and warm colors make a plane appear closer while light values and cool colors make it recede. This rule may reverse when planes overlap.

These two diagrams show the same basic shapes, but with the colors of the planes reversed. Notice how discomforting the illustration at right is. Because warm dark tones generally appear near, the position of the brownish plane is very hard to fit into our habitual ways of thinking.

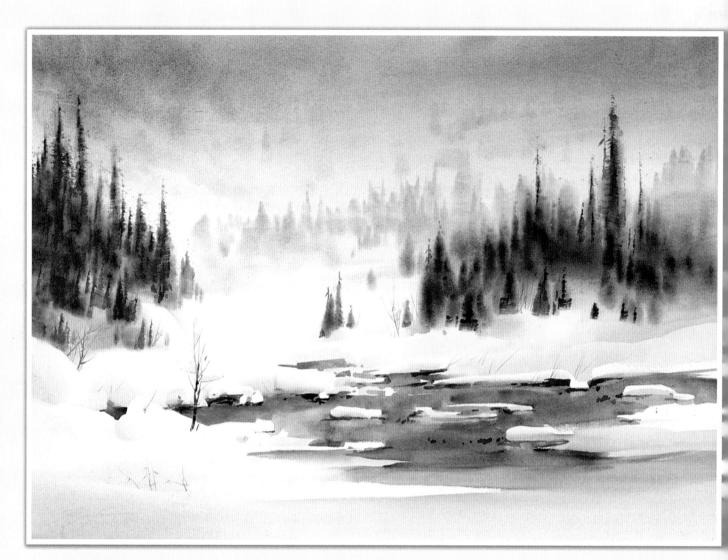

Snow Cocktail 19" × 28" (48cm × 71cm) Collection of Papierfabreik Shut Bv.

4

Basic Techniques at a Glance

his section is designed to show you many of the most useful watercolor techniques at a glance. Some of these techniques appear repeatedly in this book, and I have included examples of how each technique is used in the paintings in chapter 5.

Basic Techniques

Wet-and-Blot Lifting

When a large area is painted with a dark color, small areas can be removed to reveal light shapes with this technique. If the color is of a nonstaining combination, a soft or bristle brush may be used. However, if the color is somewhat staining or strongly staining, a firm bristle brush is necessary to get the job done.

In both cases the brush must be dripping with clean water. With the wet brush, scrub the desired area until the friction and the water loosen the dry pigment. Immediately absorb the liquid with a bunched-up tissue, removing the loose pigment with the water. Under no circumstances should you allow the loose color to sit on the scrubbed surface for any length of time. It might soak back into the fibers of the paper, never to lift again.

Not having enough water in the scrubbing brush invites disaster. A merely damp brush can only rough up the surface and will actually scrub the paint into the paper. Part of a large scrubbed shape may start drying before you have a chance to blot it, so it's better to scrub small areas at a time. It won't take long to loosen and remove the color on these small sections, and by repeating this step, you can spread the small shapes slowly until all the desired area is lifted.

Lost and Found Edges

When a wet brushstroke is painted onto a dry paper surface, all its edges are sharp. Each edge reads equally well. Shortly after application of the stroke, a thirsty, damp brush can be dragged through one edge to blend it away. This brush needs to be dry enough to soak up some of the wet color on contact, but wide enough and wet enough to moisten the dry paper next to the stroke.

I find a slant bristle brush ideally suited for this job. Its hairs cling together and tend not to hold much water, but when pressed a little, it will dampen the dry paper in its path as well as absorb some of the wet color. However, any brush can do the job with just a little practice. Make sure that the thirsty brush is dampened with crystal clear water to lose the edge completely.

The descriptive name comes from the fact that as you blend one edge, it will "lose" its importance and will simultaneously "find" the other sharp edge as a strongly visible element.

A stroke is laid down with a flat brush.

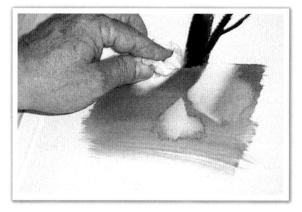

A wet brush scrubs the nonstaining color, which is immediately blotted up with a clean tissue.

A thirsty, damp slant bristle brush dampens the dry paper and absorbs some of the color, softening one edge.

Examples of lost and found edges in chapter 5: Rolling Surf, Trees in Heavy Snow, Young Spruce in Snow, Mist, Winter Island, Negative Shapes

Examples of wet-and-blot lifting in chapter 5: Shadows on Snow, Warmly Lit Snow, Heavy Fog

Back Runs

A back run is one of the most common happy accidents in painting. It happens when an already applied color is drying and some extra water touches the wash.

When water comes in contact with a color that is almost surface dry but the paper underneath is still damp, the underlying paper attracts the water and causes it to spread rapidly. As the water expands, it moistens the applied paint from the bottom, causing it to move with the water. As soon as the volume of water cannot spread any further, it stops, and the color is deposited on the perimeter of the shape as a darker outline.

When this happens you have several choices: incorporate it into the design, try to repair it or start all over. My first choice is to try to use it as a new design element, second is to repair it after it dries, last is to abandon ship.

I think of the back run as an expansion of wet technique and use it to excite my painting. Because the timing must be exactly right, you have about thirty to sixty seconds to act. Don't try to be perfect during this short period, just go for it. The more water you use, the wider the back run will spread. Practice this with a daring attitude. The darker the background, the more the back run shape will contrast.

Charging a Wash

A wash is the application of wet watercolor to a shape or area. The paper may be dry or pre-moistened, but the applied wet color is still called a wash.

Charging a wet wash means that another color is painted into a wet wash with plenty of paint as well as water in the charging brush. If the charging color is lighter than the original wash, the application may have to be repeated several times before the new color can truly replace the first one. In this case the charging brush needs to be rinsed and wiped clean after each contact with the first wash to prevent polluting the new color.

To make sure that the charging brush is capable of holding lots of water, use a soft, full-haired brush.

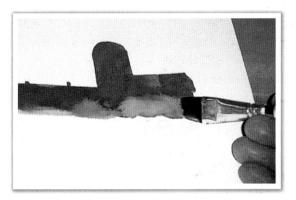

A light color is charged into a dark wash.

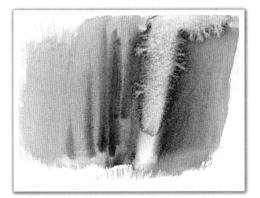

You can see the color sediments deposited all around the edge of the wet area. The result is a back run.

Examples of back runs in chapter 5:

Trees in Heavy Snow, Background Forest, Winter Island, Frost on Trees, Charged Washes, Tree Impressions

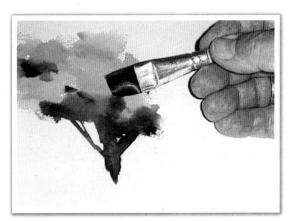

A dark color is charged into a light wash

Examples of charging a wash in chapter 5: Jagged Granite Rocks, Background Forest, Charged Washes, Colorful Darks, Rock Setting, Soft Lifted Trees

Basic Techniques

Brush Handle Scraping

The end of most aquarelle brush handles are cut on a slant to accommodate scraping. This slanted edge is very useful when you need to scrape a sharp light shape out of a moist, usually dark, background.

Because of the oval shape of the slant, the longer edge can scrape out a wider shape while the tip will remove a narrow line. For example, the broad side can scrape out a tree trunk and the tip will look after the branches.

Press hard but not hard enough to break the edge. Remember, it is only plastic; don't treat it like metal. However, if you should accidentally chip it, you may recover a new edge using sandpaper.

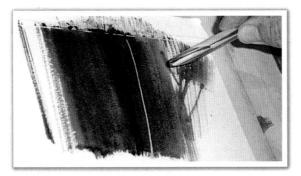

A wide area is scraped with the broad slanted side of the handle.

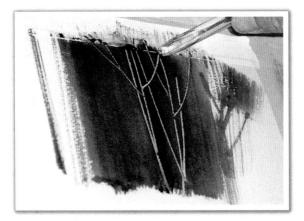

Narrow lines are scraped with the tip of the handle.

Using a Palette Knife

The function of this little tool is twofold: it can apply or remove color. First, be sure you have a palette knife like the one shown. It is important that the handle stem has a bend in it to accommodate your fingers as they grip the handle. Because the metal blade is treated with greasy material to protect it during storage, you need to clean it with toothpaste before use. The blade must allow water (liquid paint) to adhere to its surface.

The flat back of the blade can tap on a very free drybrush-like texture. The coarseness depends on how rough your paper is.,

The rounded and flexible tip of the blade is ideally suited to paint narrow lines like branches.

The edge of the blade can deliver a hairline shape when cut into the paper, releasing just enough color to make its groove visible.

For graded lifting, you must press hard at the heel of the knife and release the pressure gradually toward the blade's tip.

At the head of the blade (the widest part), the knife stops being flexible. This is the strongest useful spot for removing wet color. The only way you can lift out a sharp negative shape from a wet background is with a firm tool like this part of a palette knife.

> To deliver strong pressure you must grip the knife handle between your thumb and fingers. Never hold the blade between your fingers because you lose strength and your fingers transfer some oil to the blade.

Examples of using a brush handle in chapter 5: Birch Trees, Heavy Fog, Colorful Darks, Rock Setting Examples of using a palette knife in chapter 5: Birch Trees, Pine Branches, Jagged Granite Rocks, Rounded Glacial Rocks, Trees in Heavy Snow, Rolling Snowbanks, Smooth Tree Bark, Rough Tree Bark, Glazed Tree Bark, Rock Setting, Palette Knife Trees

Lifting Out Color

This technique can be used to lift color from a moist surface or from a dry surface.

While a wash is still damp, the color is vulnerable to touch. If a thirsty (damp) brush, paper tissue or anything solid touches the wash, it will leave a mark. Repeated brushing at this stage with a brush dipped in clean water may recover the paper close to white, unless the colors are staining.

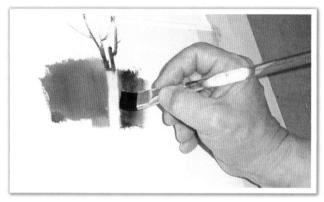

The tree trunk shape is removed with a soft flat brush.

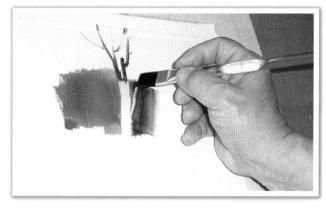

A smaller branch is removed by stroking upward with the flat tip of the brush.

Luminous Opaque Colors

Even though watercolor purists will deny using opaque colors, they will quietly admit to painting with Cadmiums, Ochre, Cerulean and a few others that fall into the category of opaque pigments. Opaque colors, except the very dark ones, are reflective. That means they are capable of reflecting light from their surface, while the transparent hues let the light go through to the paper and the paper supplies the reflected light that makes them glow. Some of the most intense colors are opaque by definition, but we still use them diluted with water. This way they are almost transparent, but when they are glazed on top, they may partly cover the colors under them.

There are subjects, such as fog, where the opacity of a color imitates the behavior of nature. Fog is a filter like a semiopaque wash. Fog makes white objects behind it look darker; so can an opaque color. Fog covers dark objects to some extent; opaque paint does, too.

Some colors are reflective enough to do the job by themselves: Cobalt Blue, Cerulean Blue, or Naples Yellow, for example.

Titanium White is a very useful ingredient for a semiopaque wash. It mixes with any colors and transfers its softening qualities even to the most transparent hue. It does a good job as a glaze on top of a dry color, or it can be mixed with other colors.

Examples of lifted-out color in chapter 5: Wispy Clouds, Cobweb, Rock Setting Example of luminous opaque colors in chapter 5: Heavy Fog, Mist

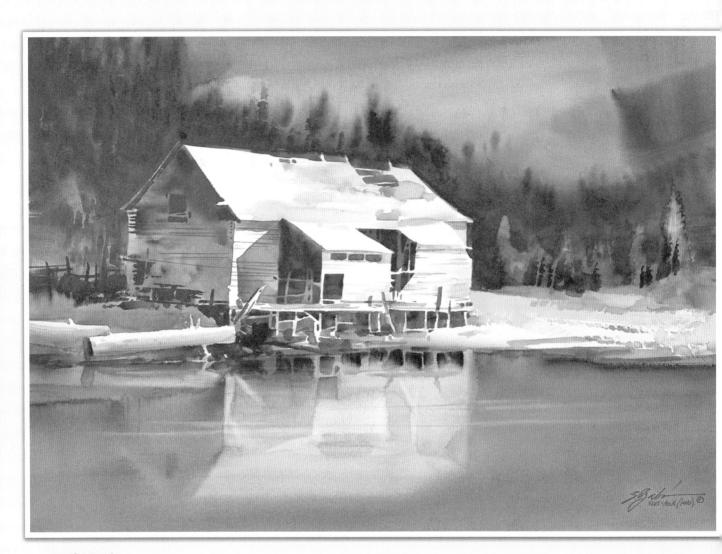

Pacific Castle 19" × 28" (48cm × 71cm) Collection of Eric and Nancy Slagle

5

Watercolor Techniques for Painting

Wispy Clouds

For the graceful softness of these clouds, you need a dark background so the light shapes will show up. Your wash must be rich in consistency but not drippy. Timing is essential; measure it in seconds, not minutes.

In the following techniques, I use mostly Blockx colors with some Winsor & Newton exceptions. Where pigments have changed or been discontinued a new one has been substituted.

The 2-inch (51mm), soft flat brush is vertical, and the paper is just damp. Drag the brush through the moist color with a back-and-forth twisting motion while gradually and simultaneously releasing the pressure. Repeat this technique several times, wiping the brush clean after each application.

The sky is a loosely mixed wash of Magenta, Gold Ochre, Burnt Sienna Light, Ultramarine Blue Deep and Cyanine Blue. I squeezed all the water out of a soft 2-inch (51mm) flat brush and rolled the edge of this thirsty brush with gentle pressure into the damp color to lift out the wispy cloud shapes. After each contact, I wiped the brush clean with a tissue, then repeated the action until I was satisfied. I didn't touch the shape of the mountains and added a hint of the grassy foreground with fast, decisive brushstrokes using Gold Ochre and Cyanine Blue.

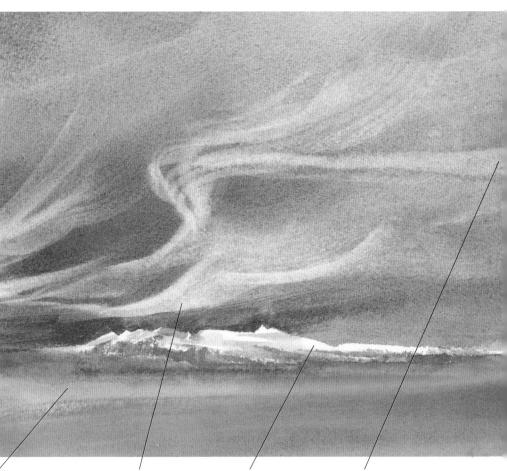

Wet-into-wet warm color complement Brushed several times with a thirsty, damp brush Negative shape left white

Brushed only once with a thirsty damp brush

The big difference between the sketches on these pages is the sky. This one is dominated by Phthalo Blue. The color of the lifted clouds ended up blue because the Phthalo Blue is staining. On the first sketch, the sky is a neutral color and therefore lifted white. In both cases it is essential to wipe off the lifted color and squeeze the brush thirsty dry after each contact with the damp paint. This way you won't dirty up the clean, wiped clouds.

This paper is barely moist, the shine just about to go dull when you move the 2inch (51mm) soft flat brush through the damp color with a back-and-forth twisting motion lifting off the light clouds. Press the damp and thirsty brush a little harder at first, then release the pressure gradually until the brush is completely off the surface. Repeat this several times, wiping the brush clean each time.

Thirsty, damp brush marks rolled into damp color

Simultaneously applied dark cool and light warm colors

Overlapping thirsty damp brush marks

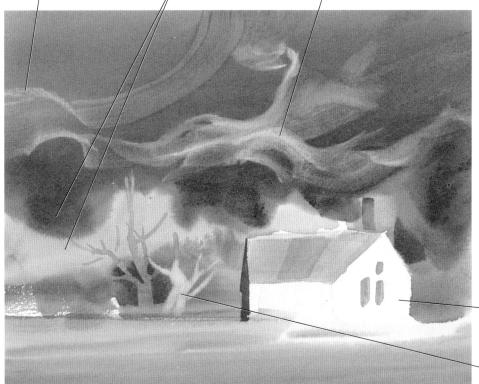

The dark sky is a combination of Phthalo Blue and a touch of Gold Ochre. I swept out the clouds the same way as in the first picture. The very dark sky created strong contrast and intense drama. I left the shape of the house white and washed the trees behind it as well as the foreground with Gold Ochre, Rose Lake and Phthalo Blue in varied combinations.

- Negative shape left paper-white

- Light shape lifted out after drying Phthalo Blue staining dominance

Cumulus Clouds

Because the soft edges of the white clouds are painted with a strong staining color, the edges must be achieved with dark colors and decisive motion. Don't expect to go back and fix them; you won't get away with it because of the staining nature of the pigment. If you lift the color later, you'll get a blue tint.

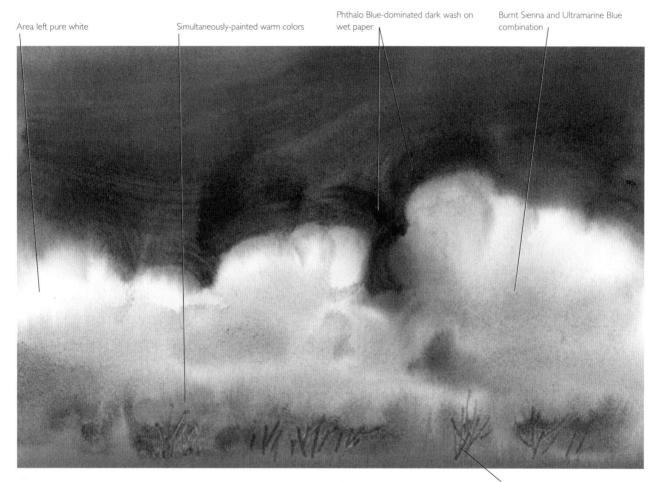

On a wet paper, I used a 1-inch (25mm) slant bristle brush loaded with a very rich mix of Phthalo Blue and Winsor & Newton Sepia to paint around the top edges of the white clouds. Because my paint was very thick, the edges simply softened but stayed readable on the damp paper. For the bottom section of the clouds, I painted the gray mixed from Burnt Sienna and Ultramarine Blue Deep. I dropped in a bit of green grassy area (Phthalo Blue and Gamboge Yellow) and hinted at a few autumn trees (Gamboge Yellow and Burnt Sienna). The darker lines indicating tree trunks at the bottom were scraped into the still-wet paint with the round point of a small brush handle.

Lines scraped into wet paint with the point of a round brush handle

Stratus Clouds

The light colors must be built up by going from the paper white to light colors and to darker colors last. Each time you add value to your brush, keep the light shape next to the brushstroke in mind and think of the negative shapes while you paint.

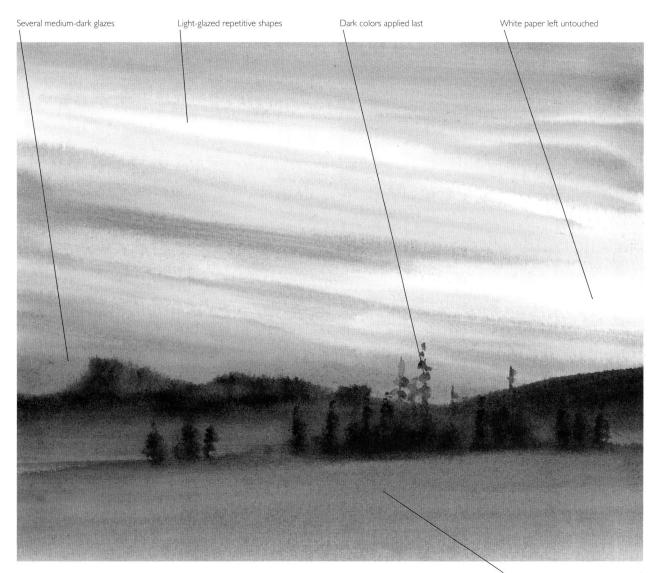

On a wet surface, I treated the windswept clouds as negative shapes. Negative shapes are "left out." They are defined by painting darker colors next to or around them. I brushed in a combination of three analogous colors: Ultramarine Blue Deep and Cyanine Blues and Phthalo Green in varied dominance. For the dark edge of the middle ground, I applied Phthalo Green, Ultramarine Blue Deep and Rose Lake, plus a little Gamboge Yellow for the grassy foreground.

Warmer ground color

Dramatic Clouds

This effect requires a color removal technique. Don't leave your wet colors on the paper too long before you use the tissue to lift them off. The more quickly you act, the whiter the clouds will look. It is important to change the tissue after each contact to prevent reprinting the color you have just lifted off.

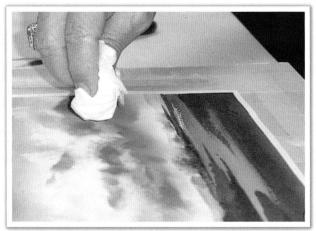

The wash is shiny wet, but not dripping. Repeatedly press the bunched-up paper tissue into the wet paint, lifting off the cloud shapes. Repeat the contact but turn the tissue each time to make sure that only a fresh and clean part touches the paint.

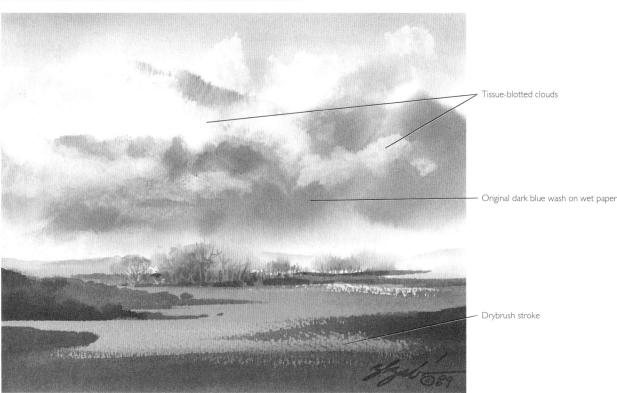

I used Cyanine Blue, Rose Lake, Burnt Sienna and Gamboge Yellow for my colors. I painted the sky and the high mountains on a wet surface simultaneously. Cyanine Blue, Rose Lake and a touch of Burnt Sienna supplied the right combination for the background. I lifted out the white clouds by pressing a bunched-up paper tissue into the wet paint. The tissue absorbed the water and paint immediately and surface-dried the paper wherever it touched. I also dropped in warm-colored autumn trees and several glazes of dark warm washes in the foreground to show color perspective.

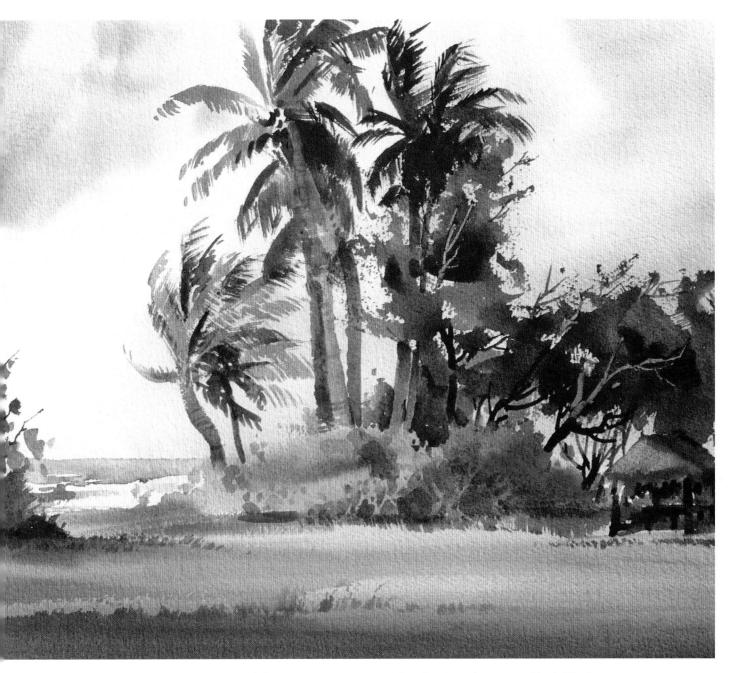

One of the most important sections of this Hawaiian painting is the sky. To indicate breezes, I established the windblown clouds by *not* painting them. Instead, I painted the blue sky around them on wet paper, leaving the clouds' edges soft. Against this light background, I painted the contrasting palm trees. Their branches bend with the wind. I painted these branches with a slant bristle brush loaded with rich pigment and little water. I drybrushed most of the dark vegetation in cool shadow colors. Last, I painted the sunny foreground with warm colors on the grass. The energetic shapes of the trees shows very well against the fresh background.

Trade Wind 15" × 22" (38cm × 56cm)

Birch Trees

This technique can be used to paint many kinds of light-barked trees, especially against a dark background. The color you choose for your background will affect the color of the light trees. Because Rose Lake (a light staining color) dominated the area where I removed the shapes of the light birches in the background, its staining dominance shows up even after the color is squeezed off. Whatever light color you want to show in the scraped-out shape, that's the one that must dominate the background color to start with.

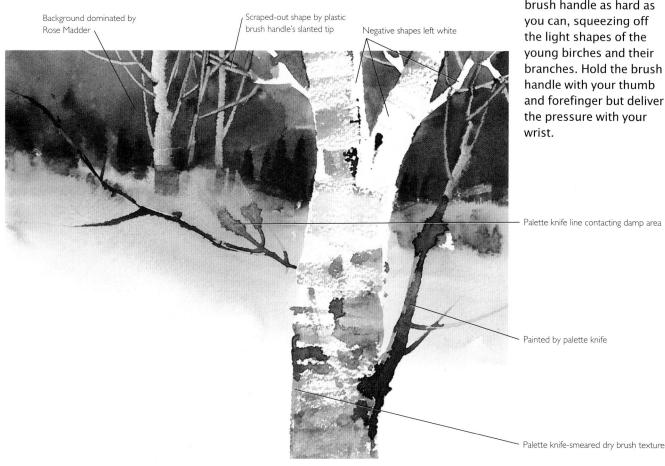

I painted a rich dark background onto dry paper, leaving a negative shape for the foreground tree. I used Gold Ochre, Rose Lake and Ultramarine Blue Deep. While this thick wash was still tacky wet, I lifted off the distant birch trunks with the tip of a plastic brush handle. Then I drybrushed the texture of the birch bark by quickly dragging across the colors with the edge of a palette knife. I applied the larger branches with the tip of my palette knife, held vertically to allow the liquid paint to flow off as I moved the knife away from the trunk.

On a wet background, press the slanted edge of the tip of a plastic brush handle as hard as branches. Hold the brush and forefinger but deliver

While the background wash is still wet, use the slanted tip of the brush handle to remove the birch tree shape. Hold the brush with a firm grip and press with your wrist as hard as you can. Hold the flat oval part of the acrylic brush handle at a 45-degree angle to smoothly squeeze the color off without ripping the wet paper.

last

Tap the palette knife's edge and its flat back onto the dry white paper to do the peel marks and drybrush texture at the same time. Use varied liquid colors. Wet paint produces solid shapes; the less water in the paint, the finer the texture.

Staining blue showing through scraped-out light shape -

Warm tone was added after background color had dried

cool colors

Though the procedure here is similar to the sketch at left, this time I painted the background with a varied dominance. As you can see, the scraped-out light birch retained the same characteristics in much lighter values. The longer you wait to do the scraping, the more time the setting colors have to stain the paper, reducing your contrast.

Overflow of color moved from lower dark background colors by brush handle

Branches scraped out with back of brush handle -

Warm accents against cool dominance

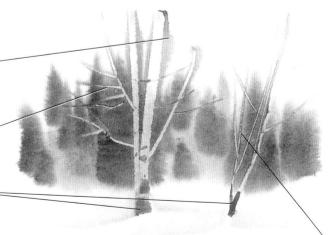

I left the upper third of the painting white. As I squeezed the color off, the brush handle acted like a small bulldozer pushing the wet color in front of itself. In a dark background this color simply blends away. However, here the color was deposited on the wet, white background as the brush handle entered it. This free and loose accent engaged the edge and prevented the sketch from becoming an unpleasant vignette design.

Branch shapes were scraped out with brush handle while paper was damp, but not wet

"Positive" branch shape was painted last with rigger Background was painted first, leaving tree trunks white Colorful drybrush shapes were added

Pine Branches

Most pine branches have little elbows close to the trunk, and the branches reach the needles from the bottom, holding them up with their fingertips. The top of the needle clusters need to be painted with a richly loaded dry brush flipped upward and away from the paper to show the needle-like finish. Do these brushstrokes quickly and decisively. Don't pick at them.

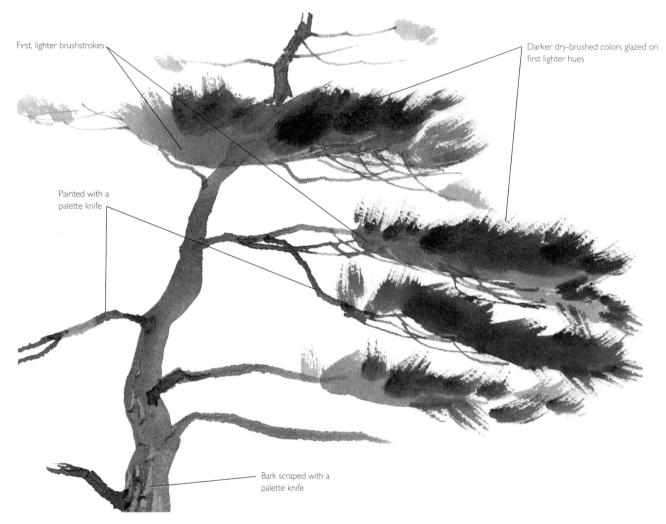

I painted the branches with a palette knife using liquid-consistency paint and drybrushed the foliage with a 2-inch (51mm) slant bristle brush filled with dark paint. My colors were Gold Ochre, Magenta, Phthalo Green and Ultramarine Blue Deep.

Lifted White Trees

The high clarity of the white trees is the direct result of my choice of an efficient tool: my nail clipper. The tip of its handle is very firm but smooth so it will not tear the wet paper. Avoid ripping the surface by choosing a smooth tool that lets you press very hard. Any thin, light lines against a dark background can be done with this technique. Frosty weeds, birch, aspen or sycamore branches and white whiskers on an old man are just a few examples. Think of techniques as principles, not isolated subjects.

This group of bleached-out light trees is formed by scraping them out of a very dark and still-damp background with the handle of a nail clipper. Hold it between your thumb and fingers and press as hard as you can with the strength coming from the wrist. Scrape the thin shapes with rapidly moving strokes before the background has a chance to dry too much.

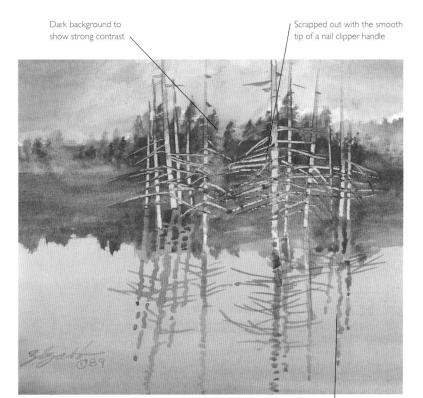

You can achieve the same effect by holding a small pocket-knife blade point on its side guided by the index finger while removing the light shapes with heavy pressure.

This little landscape started with basic washes for the sky and water. I used Cyanine Blue, Gold Ochre and Rose Lake. With the same colors in rich creamy consistency, I quickly washed in the warm-dominated distant shore trees and their reflection using a 2-inch (51mm) slant bristle brush. While this shape was still quite wet, I pressed the tip of my nail clipper handle very hard to remove the shapes of the light trees and their branches. I finished on a dry surface by painting the wiggly reflections with my rigger brush.

Glazed reflections

Weeds

To paint this colorful clump of weeds, I first washed in the neutral background color. The initial silhouette of the weed clump was painted on the dry white paper and into the still-damp wash at the top simultaneously. The edges stayed sharp on the dry surfaces but blurred when they touched the moist color. If your dark color is rich enough and you apply the color very fast, the difference will be negligible. The scraped-out weeds look colorful because the dark color behind them is dominated with separate charged colors. Therefore, the light weeds show whatever dominant colors are underneath them.

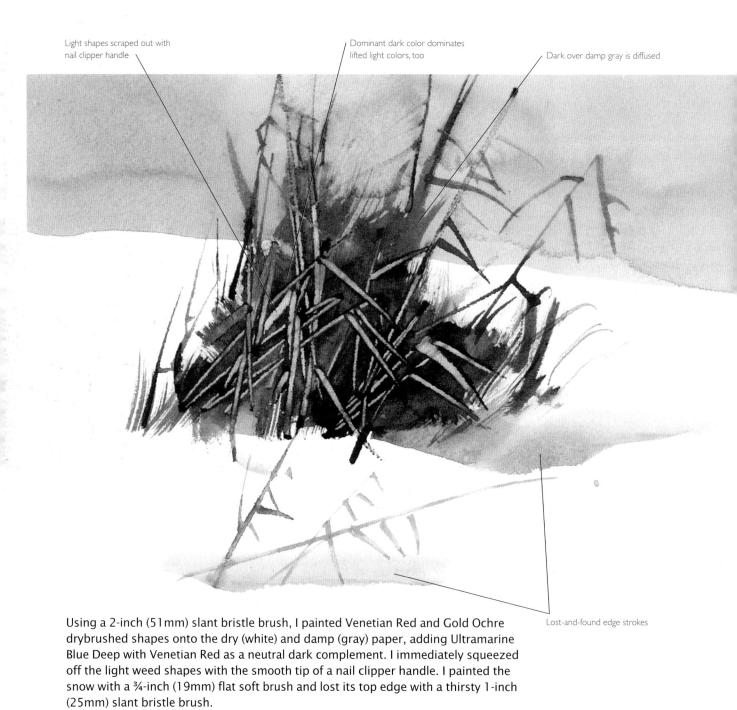

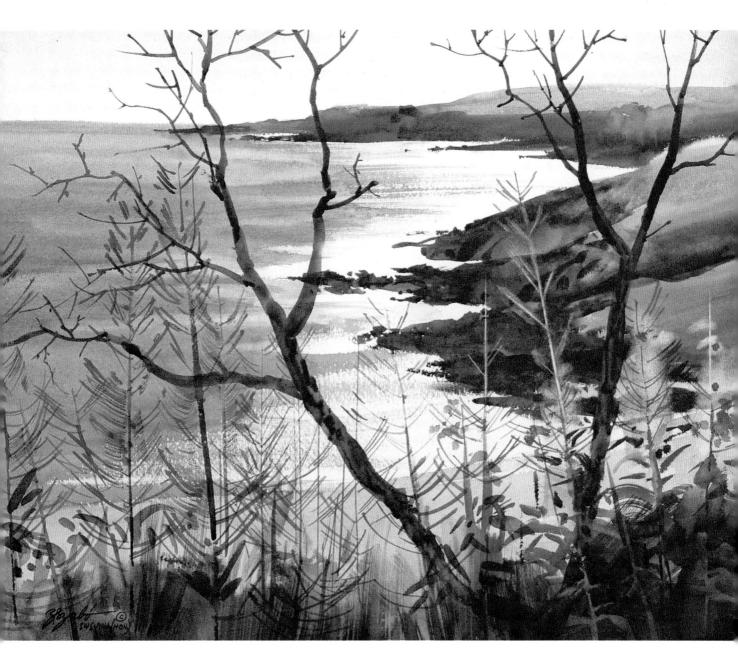

This calm but rugged coastline is a high-contrast background for the delicate fireweeds and their accompanying dark branches. I painted the sky, the coastal hills, and their rocky shores first. Then I glazed the middle value sea with a glazing technique on dry paper. I moved my brush horizontally and lifted it gradually as I approached the coastal rocks. The resulting drybrush leads the eyes to the white shimmer. Over the lighter parts of this background near the bottom, I painted the colorful lace of the firewoods. Where they crossed a dark area, I lifted off the background with a wet scrub-and-blot technique. I glazed the weeds' leaves with dark glazes and finished the painting with the dark tree and its fine branches.

Scottish Autumn 13½" × 17½" (34cm × 44cm)

Flowering Trees

Here is a quick wet-into-wet technique. The dark background is painted first on wet paper, leaving the soft main shape (in this case, the flowering tree) as a negative shape. For this or any similar subject, make sure that the negative space stays perfectly white while you paint the dark color around it. Use less water in your brush than there is on the paper. To get the soft mauve color, the flowering tree had to be painted on white, not dirty, paper.

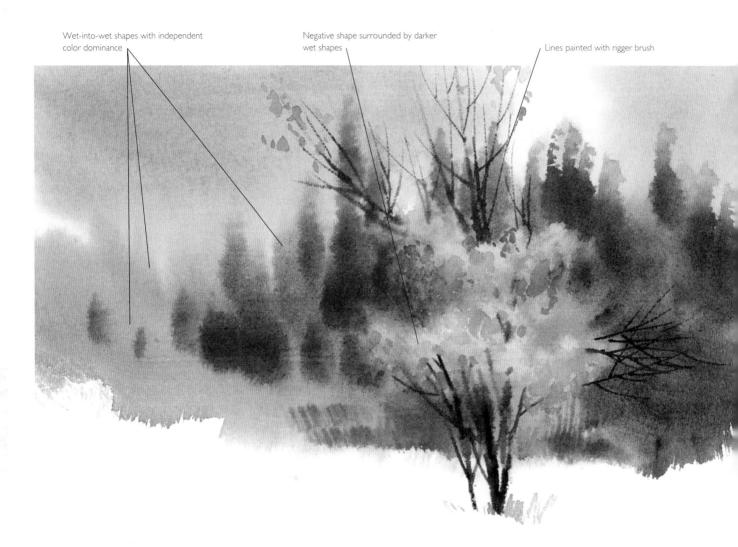

While the paper was wet, I painted around the flowering tree shape. The sky color came from Cyanine Blue and Phthalo Green. For the gray at the left, I added a little Rose Lake and Gamboge Yellow. I painted the dark evergreens Phthalo Green, Gamboge Yellow, and Rose Lake. As the surface was losing its shine, I dropped little rosettes of water and a small amount of Rose Lake into the irregular white shape left for the flowering foliage using a no. 5 rigger brush. The trunks and the branches came when the paper was almost dry. Note that I surrounded the flowers with the darkest colors to exaggerate the contrast.

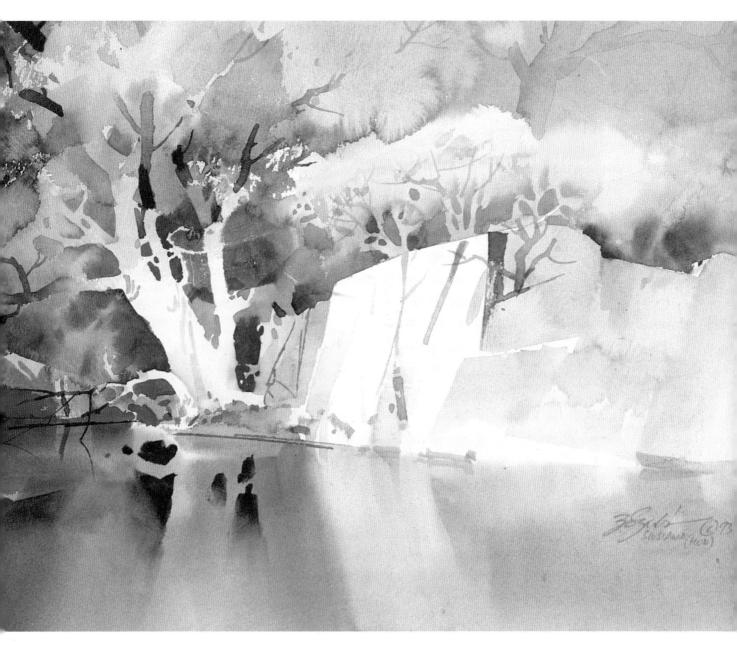

In this painting, the dominant strength of white surrounded with rich, dark values and colorful shapes created a powerful focal point. Starting on dry paper, I carefully painted around the white network of rocks and the big white tree. I painted the foliage and the background with several colorful glazes, allowing some of them to create loose back runs suggesting foliage clusters. My darks evolved gradually next to the whites to emphasize their brilliance. After all the images were finished, I painted the water and reflections in medium value with a few dark accents where my contrasting focal point needed it. Happy Glow 15" × 20" (38cm × 51cm) Collection of Willa McNeill

Jagged Granite Rocks

Here's another chance to use your palette knife to describe shapes. But remember: Your knife must be held firmly by its handle while your wrist delivers the necessary heavy pressure. Never hold the blade with your fingers; they aren't strong enough to squeeze off the colors. Use the widest part of the blade (the heel) because that is where the metal is firm enough to do the job.

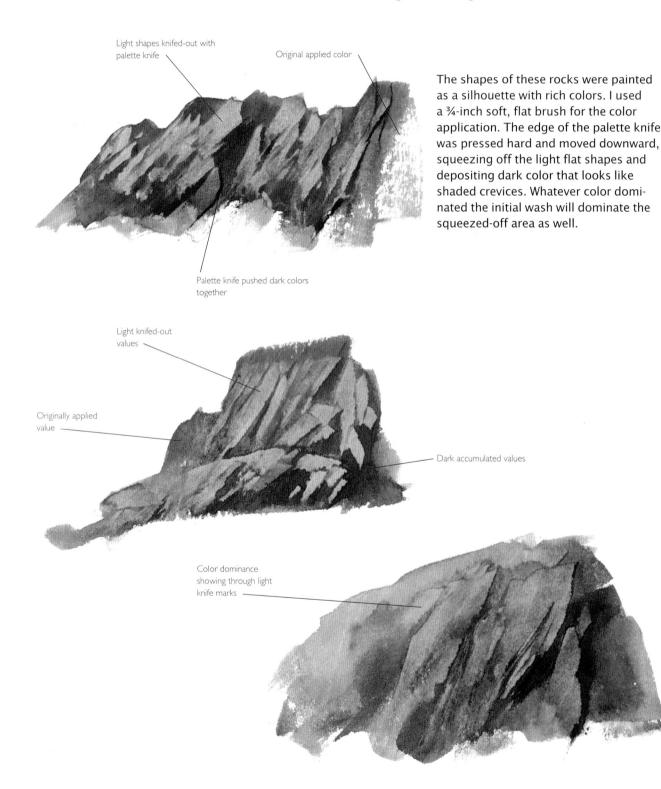

Rounded Glacial Rocks

These rounded rock shapes are similar to jagged rocks but the movement of the palette knife is different. For best results, use paint with a thick, creamy consistency for these shapes. Holding the knife by the heel and the tip pointing down, press hard at the heel and gently lift towards the tip while lifting off the color. This tilt will produce the textured transition from the lightest to the darkest value. If your color is too runny, the wet pigment may gush back to the path of the knife.

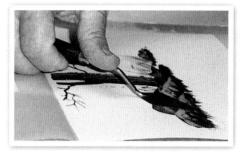

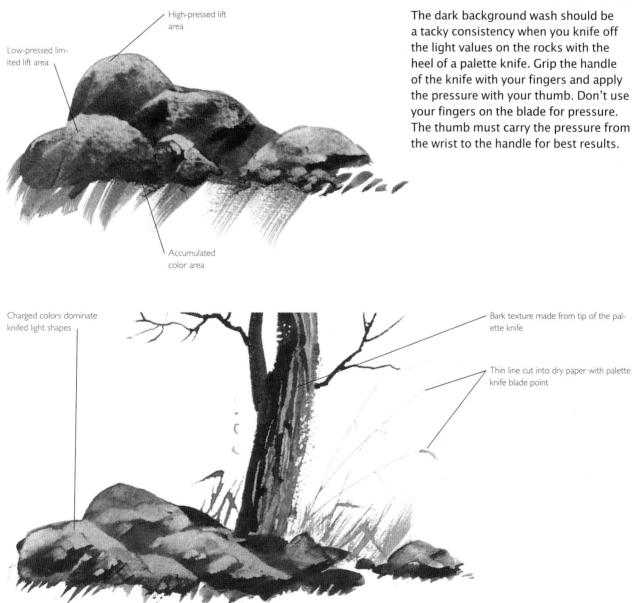

These rounded rocks were all painted with a ¾-inch (19mm) soft, flat brush and textured with the heel of my palette knife. I used complementary colors to establish their natural color shape and value. My colors were Ultramarine Blue Deep, Rose Lake, Gold Ochre, Burnt Sienna and Winsor & Newton Sepia. I did not scrape the wet color but squeezed it off with the firm heel of my brush.

Rolling Surf

It's hard to figure out exactly what rolling waves look like because they constantly move. As the surf rolls over, its top edge is sharper and straighter and the bottom edge is broken up and more curved. This "lace" is best painted with the flat side of a soft brush used as a dry brush. While doing this, press very lightly. The bottom edge is a free shape. Let the brush show off the looseness of its natural hit-and-miss tendency.

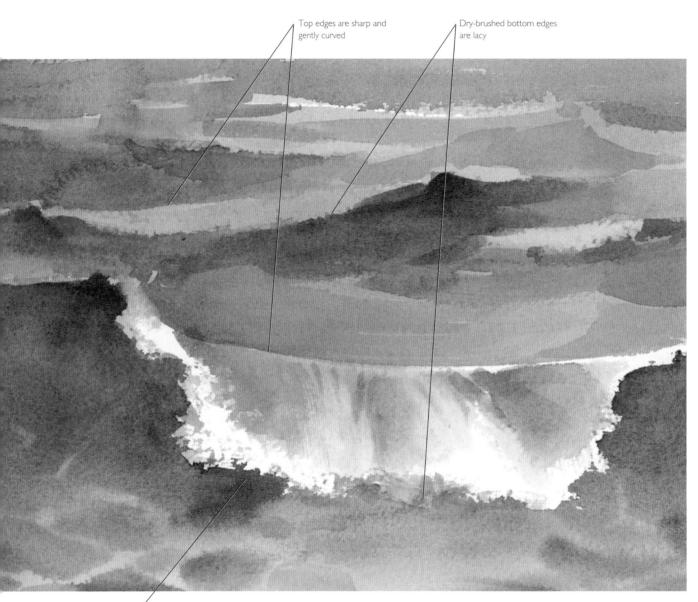

Darkest color next to foamy white

I painted the surf as if it were a tube-like wave. I quick-brushed my rich glazes and allowed some of the white surf heads to stay white. I added a quick touch of dark to the damp lacy underside and another one to the top edge of the white shape. My colors were Cyanine Blue, Gold Ochre, Cobalt Green and Van Dyck Brown.

Puddle Reflections

The shapes of puddles are viewed in a foreshortened perspective. Many students, knowing that puddles often are round, fail to flatten them enough, as they would look when viewed from a normal viewpoint. These flat shapes may be pointed or oval but never a circle. Puddles make the best design elements when they are painted in high contrast. If they are in the same value as the surface next to them, they don't stand out and you are better off eliminating them.

Dominant dark value

A puddle is a small reflective surface. The color and value of the reflection of the tree combines with the local color, in this case the light gray muddy bottom of the puddle, which is lighter than the tree trunk or even the soil. Therefore the reflection of the tree is lighter than the tree. My colors were Ultramarine Blue Deep, Rose Lake, Phthalo Green, and Gold Ochre. Note how the reflecting surface stops abruptly at the edge of the puddle. Reflection dominated by deepest value and color of the local color (mud) Negative shapes were left clear

Shadows on Snow

This technique is very sensitive to the brands of paper you use and the brand and choice of color. It works best on a well-sized surface with artists' quality nonstaining watercolor. Check the definition of nonstaining colors discussed in chapter 1.

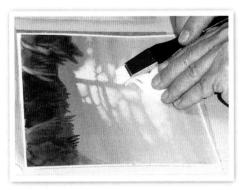

For the dry shadow, use a small bristle brush loaded with clean water to remove the color and show patches of sunlight. To make the blurry edges, move the brush faster and for a shorter time, blotting off the floating pigments immediately.

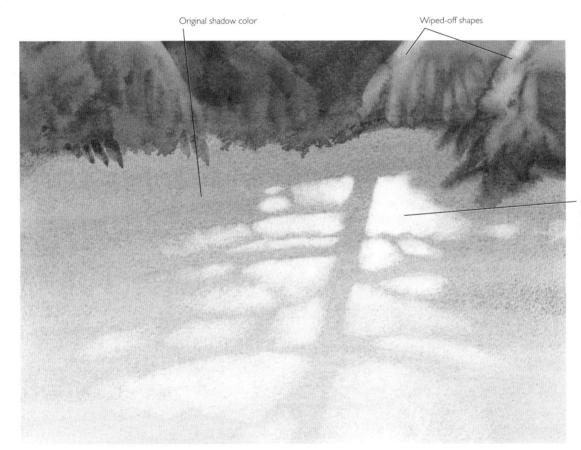

Islands of light shapes lifted out of wash of nonstaining colors

I painted the snow surface as if all of it were in shade using Manganese Blue with a touch of Cobalt Violet on the dry paper surface. After the color dried completely, I treated the shadows as negative shapes and removed the sunlight shapes by loosening the dry paint with a very wet, small oil painting brush and blotting it off with a bunched-up dry paper tissue. This is the wet-and-blot technique. Note that the light patches are islands of white and the shadows were left untouched from the original wash.

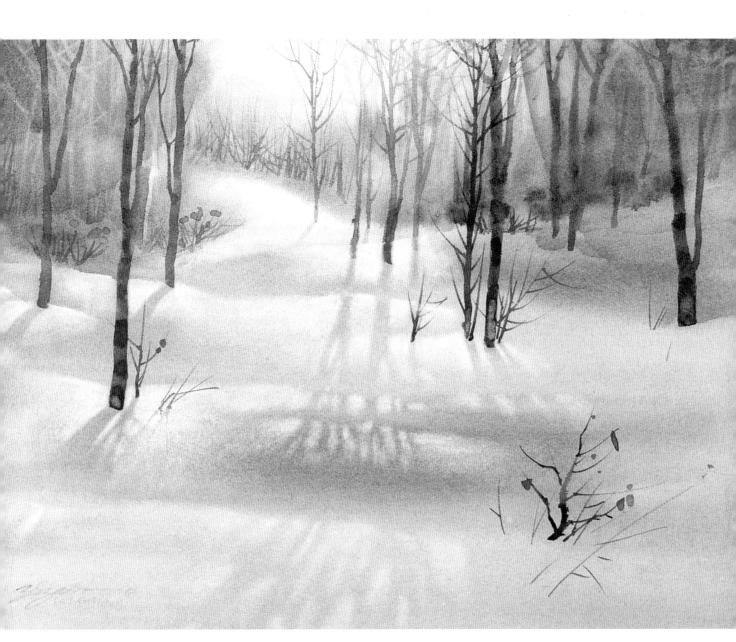

To lift the sunlight off the snow, I used my little bristle scrubber filled with clean water and loosened the pigment in just a small area at a time. I started at the top of the hill where the light is the strongest. I made sure that the shadows stayed intact, lifting out only the islands of light. The edges of the shadows closest to the trees remain sharp, while the shadows extending into the foreground have softer edges and less contrast. Note that all the shadows taper toward the imaginary location of the sun.

Stoic Shadows

 $13\frac{3}{4}$ " $\times 18$ " (35cm \times 46cm) Noblesse cold-pressed paper Collection of Willa McNeil

Sunlight on Snow

Instead of the backlighting seen in *Shadows on Snow*, here we see strong front lighting, sending the shadows away from us. The dark background color is made of charged lighter colors into a dark base wash. This must be achieved while the first neutral dark wash is shiny wet. Light colors replace dark colors easily when charged into very wet paint but behave unpredictably if the first wash sits too long. Play with charging colors. The bright foreground is left paper-white except for the cool shadow and lone grasses.

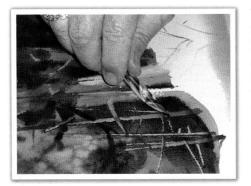

To scrape out the shapes of the light trees, use the oval tip of the acrylic brush handle. The color is applied in a rich consistency and scraped immediately. The brush handle is held firmly between the thumb and fingers but the wrist delivers the pressure.

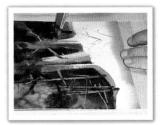

Use a 1-inch (25mm) slant bristle brush for the dark drybrush touches. The brush should be full of very dark color with very little water. For ideal results, don't press the brush too hard or you'll get a lump. Barely touch the surface and the result will be free and lacy.

Wet-into-wet, warm-dominated colors

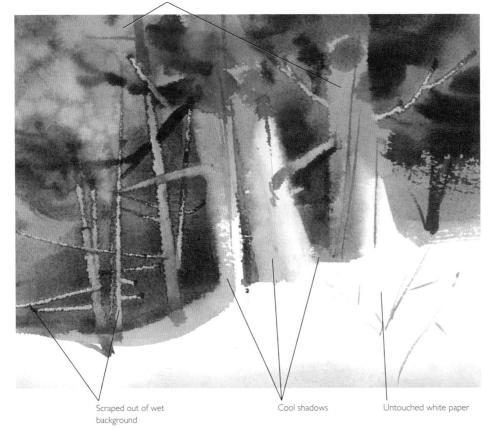

To indicate bright sunlight, I painted the dark background leaving out the large trees as negative shapes. My colors were Cadmium Red Orange, Rose Lake, Cyanine Blue and Phthalo Green in various dominance. I did the small tree trunks with the slanted end of an acrylic brush handle while the dark wash was still wet. After the first wash was dry. I glazed the shadows onto the tree trunks as well as the little weeds and their shadows.

Warmly Lit Snow

Painting warm light on a naturally cool subject is an interesting challenge. One technique is to first cover the area with a cool wash, lift most of it, and then glaze with a warm note. When you glaze a warm color over a cooler shape that was scrub-lifted, you are working over a slightly damaged surface. Make sure that your paper is bone dry and cover the surface fast with a large, soft brush. Don't go back and forth or the surface may get mottled.

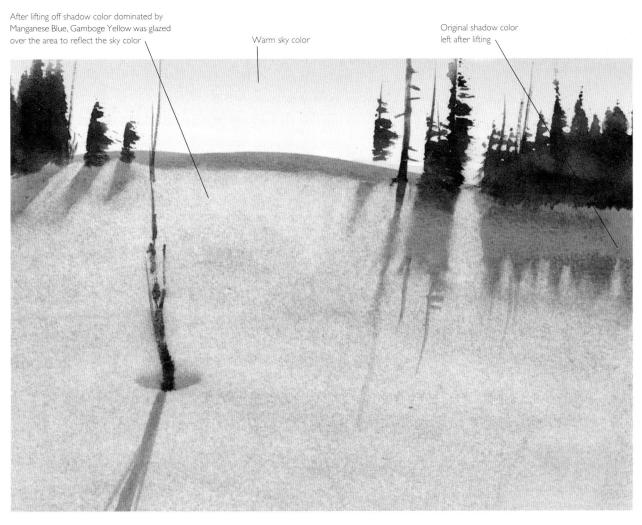

I started with the golden sky, painting the blended wash with a 2-inch (51mm) soft slant brush using a mixture of Gamboge Yellow and Rose Lake. I painted the whole snowy hill with the same blue color as the shadows and let it dry. My shadow colors were Turquoise Blue and some Rose Lake. While this was drying, I painted in the dark evergreens with my 2-inch (51mm) slant bristle brush using a strong mix of Rose Lake, Turquoise Blue and a small amount of Phthalo Green. I then scrubbed out the large foreground area, leaving the shadows untouched. Because the lifted color was too blue-white for the warm light condition, I glazed a very thin wash of Gamboge Yellow over the sunlit snow (shadows included) to warm it up.

Falling Snow

There are various ways to represent falling snow in watercolor. This salt technique is one I like, as long as it is used sparingly. There is only one trap with this technique, and it is timing. Sprinkle the salt just as the shine of your wash goes dull; you have about thirty seconds to do it. If you act too soon, the salt will dissolve and create "uglies." If you put the salt on too late, nothing happens. The effect takes about fifteen seconds to start showing. Don't be impatient and throw in more salt. Too much salt is the kiss of death. Again, don't use salt all the time, only when the technique is absolutely called for.

Carefully timed salt created these snowflakes χ

Dark shapes were painted into an almost dry surface <a>

I painted the moody background with Burnt Sienna, Gold Ochre and Ultramarine Blue Deep, using a 1-inch (25mm) slant bristle brush filled with rich colors and a little water on a wet surface. For the pines I added some Phthalo Green to the previous dark combination. I sprinkled salt into the wash just before it lost its shine. I used only a few grains of salt; more salt may create an overpowering blizzard effect.

Drybrush strokes were applied after the paper dried

Trees in Heavy Snow

I want you to look for two areas of interest in this little color sketch. (1) Most of the washes are not only light in value but clean as well. Spontaneity is the reason for smooth clarity of the colors. (2) The water droplets in the sky must be applied just as the shine of the wash goes dull. You may have slightly varying results each time, because it is impossible to match the timing to the split second. Expect the outcome to be fun, not perfection.

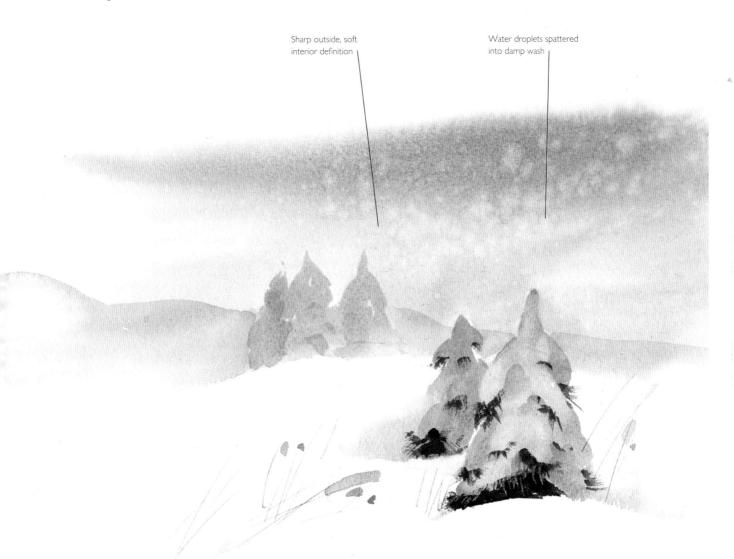

My colors were Burnt Sienna, Cyanine Blue and Ultramarine Blue Deep for the sky. I started with a Burnt Sienna and Ultramarine Blue Deep wash on wet paper. I used the slant bristle brush to spatter a few water droplets into the drying color to hint of snowflakes. Then I painted the silhouette of the snow-covered trees. After the color dried, I drybrushed the few dark exposed branches. I used the lost-and-found edge technique for shading the snow on the trees as well as on the ground.

Young Spruce in Snow

The most important element in this little example is also the most subtle one: shading the snow with lost-and-found edges. Sharp edges read clearer than soft ones. Whatever subject you paint, sooner or later you'll need to paint something that has a sharp edge on one side and a soft edge on the other. Any subject, a portrait, a figure, a landscape or an abstract watercolor, may use this technique.

Paint the delicate baby spruce branches sticking out of the snow immediately after dampening the dry paper. Use a no. 3 rigger filled with rich paint and very little water. As soon as the dark color touches the damp surface, it blurs a little to look like the fine needles of a spruce branch. It is important to apply the color with a delicate touch and just the right amount of moisture.

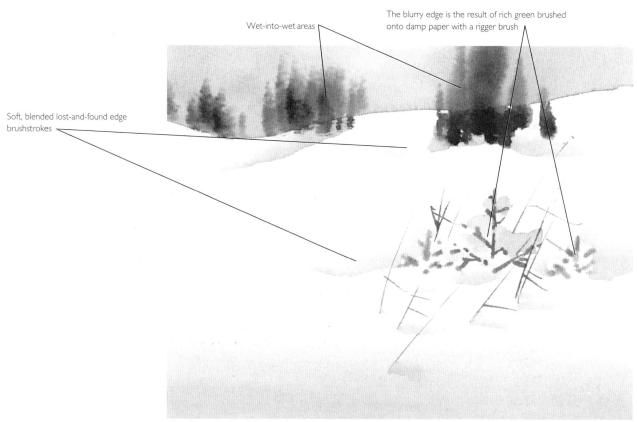

I started on damp paper with rich pigment and a little water in my no. 3 rigger to paint the fine spruce branches. I allowed the edges to soften slightly as the brush touched the damp surface. I shaded the snow with lost-and-found edges. My colors were Phthalo Green and Gold Ochre for the young spruces and Burnt Sienna and a little Magenta for the snow. I used my palette knife's cutting edge to indicate the thin weeds. In the background, I used the same colors for the sky and the soft trees.

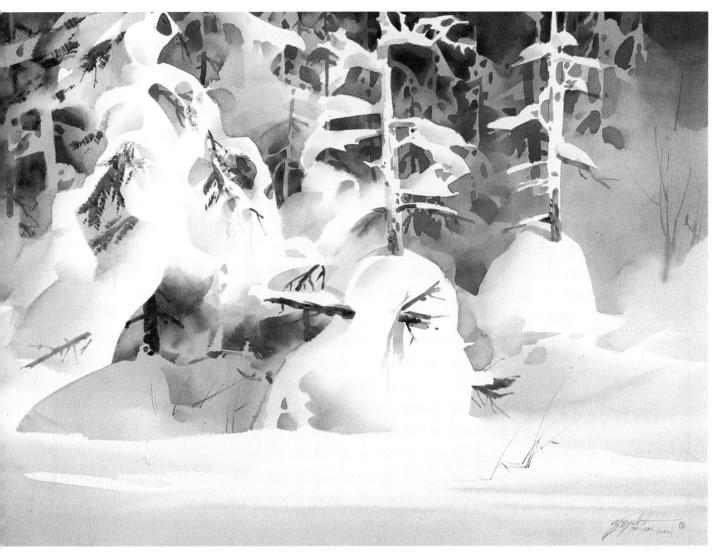

This winter scene is the result of several glazes and lots of lost-and-found edge control on the snow modeling. I started with a medium-value glaze around the white snow. This color is still visible at the top right edge. As this was drying, I painted the next darkest value, exposing the silhouette of the shaded trees in the value of the first wash. The darkest glaze at the top and the branch structures showing dark accents came last.

I shaded the snow humps by applying the shadow colors and blending away the edges facing the sun. This lost-and-found edge technique enabled me to make the snow look soft, deep and inviting. The reddish bark complements the otherwise cool dominance of the painting.

Winter Friends 15" × 22" (38cm × 56cm) Collection of Tom Malone and Susan Pfahl

Heavy Fog

Fog can create moody and mysterious visual conditions. While very close objects can be colorful and clear, other objects quickly seem to melt into the atmosphere as they move toward the distance. The shapes behind the fog must be painted first with dominating staining colors like Payne's Gray or Sepia. If your first wash doesn't stain, it will come off when you glaze the fog on top of it, no matter how gentle you are. For the fog, don't be stingy with the color. It should be about as thick as table cream but still definitely liquid. Heavy fog is painted with thicker consistency paint. "Mist" is painted with runnier paint, but is painted in the same manner. When the color dries, it will regain its luminosity.

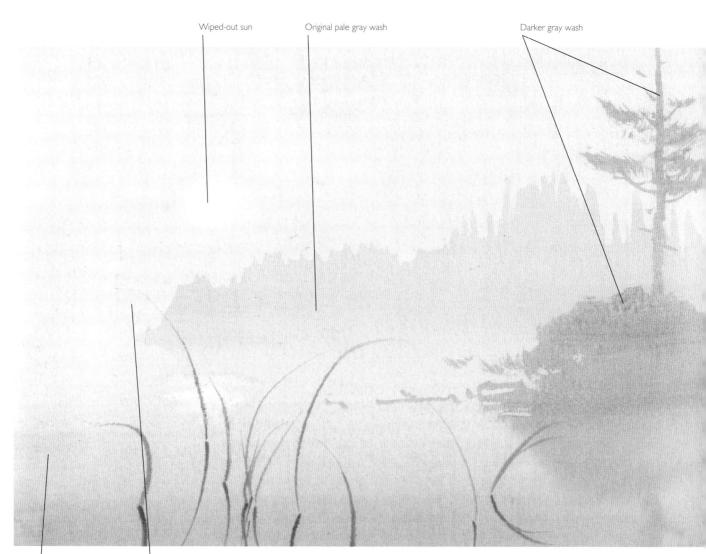

Titanium White and Gold Ochre glaze

Titanium White and Cobalt Blue glaze For this moody fog study, I painted the background trees and the dark tree silhouette with Van Dyck Brown and Payne's Gray onto my dry paper. When these were dry, I painted a rich reflective wash of Cobalt Blue, Titanium White and Gold Ochre over the original design using a 2½-inch (64mm) soft slant brush. Last, for the dark foreground weeds, I used Gold Ochre and Cyanine Blue. Whenever you paint dark colors on top of a dry but opaque wash (as I did in the foreground below), apply the color quickly to avoid digging up the light color. With repeated wet brushstrokes the color will actually get lighter. If you need to go back because you didn't go dark enough, wait till it dries again and repeat your dark color on a dry surface.

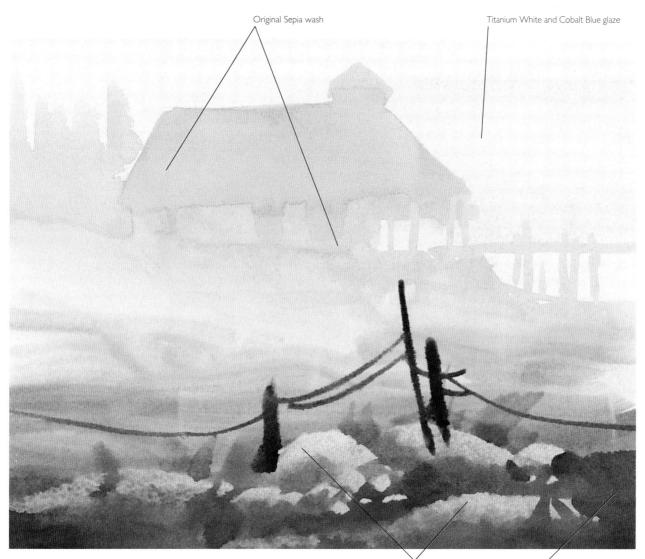

For the background building and dock, I used a thin wash of Winsor & Newton staining Sepia. After it dried, I glazed the fog on top with a mix of Titanium White and Cobalt Blue. My foreground colors, painted last, were Venetian Red, Winsor & Newton Sepia, Cobalt Blue and a touch of Aureolin Yellow for the weeds. Palette-knife-scraped light area Rocks painted and warm foreground colors

Mist

Even though the wash for the trees was painted with a staining color (Sepia) and allowed to dry, I felt safer applying the blended mist color on top of it with a half-loaded large brush rather than going back and forth many times, risking some possible loss of the Sepia wash. When the wet slant brush has paint only in the long-hair end of it and just water in the short hairs, it will blend one side of the brushstroke and leave the other end dark and sharp to read as a strong design element.

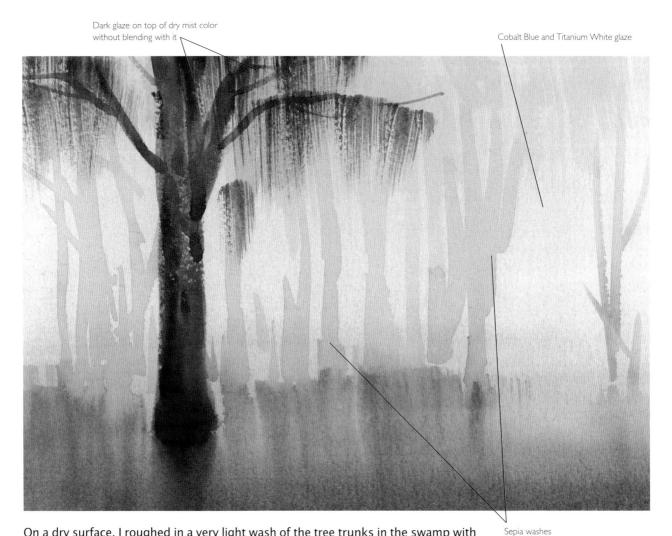

On a dry surface, I roughed in a very light wash of the tree trunks in the swamp with Winsor & Newton Sepia (a staining color). After this wash was dry, I glazed a mix of Cobalt Blue and a little Titanium White with a 21/2-inch (64mm) soft slant brush. This wash was thicker at the top and more diluted down near the bottom of the trees. The long-haired end of my brush held the thicker paint and the shorter hairs supplied the water simultaneously. This way the brushstroke blended its own edge as I applied it. Again I let the paint dry completely. The dark tree with the Spanish moss was gently glazed on with a ³/₄-inch (19mm) flat aquarelle brush without disturbing the dry mist color.

For this example I did not use white in the color mix for glazing the mist. Cobalt Blue, a light opaque (reflective) color, was my choice. Diluting an opaque color with water is like adding white paint. Water makes watercolor lighter by diluting it. The staining color of the background wash visually combines with the semiopaque Cobalt Blue wash showing the translucency of both colors. You can use this technique with any combination of opaque and staining colors on any subject where a soft misty effect is required. Remember, the strength of the colors is determined by how much water and paint is in your brush.

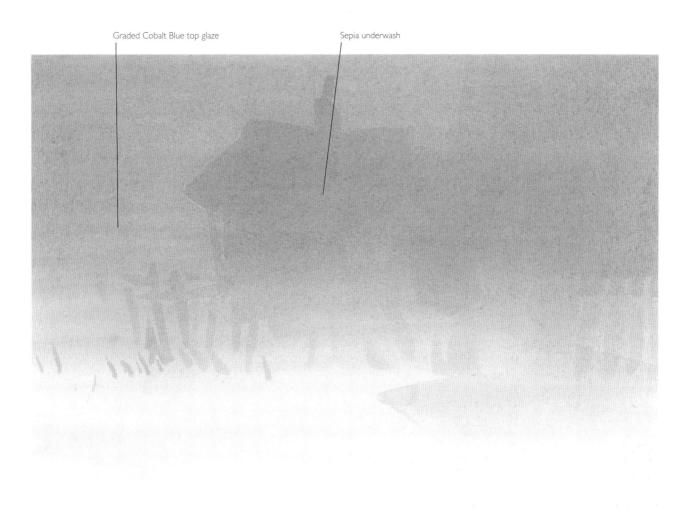

The silhouette of the building in the background was applied with a faint wash of Winsor & Newton Sepia and allowed to dry. I glazed the mist wash on top of it with a $2\frac{1}{2}$ -inch (51mm) soft slant brush loaded with Cobalt Blue at its long-haired end but only water in the short hairs. As I repeatedly moved the brush horizontally, the value of the wash got darker at the top but stayed lighter at the bottom.

Sunlight on Wood

You must use a well-sized, high-quality paper for this technique. Noblesse, Arches, Lanaquarelle and Waterford are all papers that will work. For best results, the staining color used for the wood-grain texture must be the first color to touch the paper. The less staining the shadow color is, the easier it is to remove it. Test the colors you intend to use on scrap paper before diving into a complex painting.

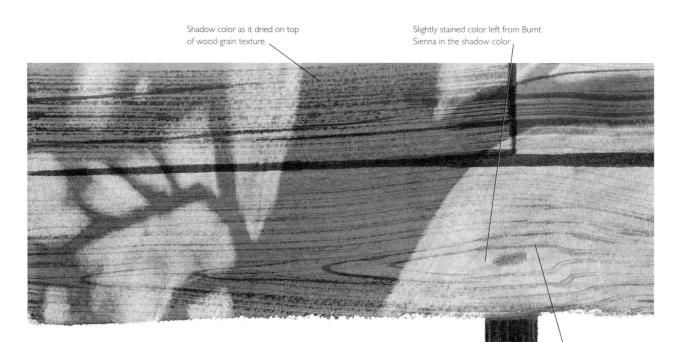

Original Sepia texture after lifting off shadow color

I applied the wood grain on dry, white paper with a 1-inch (25mm) slant bristle brush using drybrush technique. My color was Winsor & Newton Sepia, a staining color. After it dried, I glazed a rich liquid mix of Burnt Sienna, Ultramarine Blue Deep and Gold Ochre over the whole wood surface to represent a shadow value. I waited for the paper to dry and then lifted out the sunshine areas with a wet-and-blot technique. The wood grain remained unharmed.

82 Download free wallpapers at artistsnetwork.com/zoltan-szabo

Cobweb

This technique works best with a dark background. The moody interior of an old barn or an ancient castle is just the place for a romantic touch such as this. The dark surface shows off the beading, dusty appearance of the cobweb. Be sure your background wash is bone dry. You may want to blow-dry it with a hair dryer for about twenty-five seconds to make sure that any humidity that might have entered the paper from the air is completely removed.

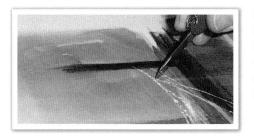

For this effect, the paper has to be bone dry. Hold the sharp tip of a small pocketknife blade firmly between the thumb and fingers at a 90-degree angle. Pressing very hard, scrape out the beaded lines with several lightning-fast strokes. It is important to use an extremely sharp blade.

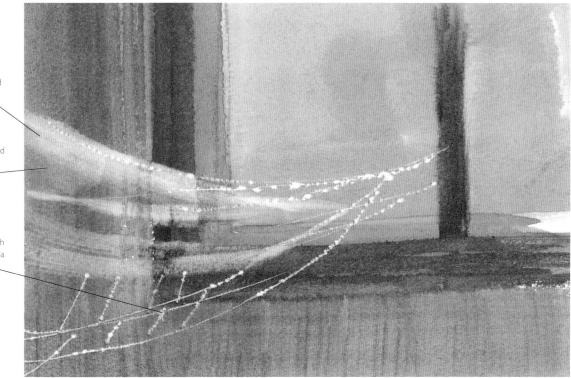

Wet brush used to scrub out dusty, soft web 🔨

Dark background shows the web better

Scraped out with the sharp tip of a pocketknife

First, I painted in the window frame as well as the gray wall next to it using a ¾-inch (19mm) soft flat brush. I kept these washes on the darkish side with Burnt Sienna and Ultramarine Blue Deep. I followed with the outdoor sky color, Cobalt Blue, with a little Aureolin Yellow near the bottom. After everything was dry, I scraped out the thin lines of the web with the very sharp point of my pocketknife. I held the knife on a very high angle. This way I got caught in a few places making the impression of a beaded line. I linked several of these lines together to make it look convincing. To make the web a little older and dustier looking, I wetted and quickly wiped off some of the color for the soft light shapes complementing the white lines.

Simplified Planes

This is an excellent technique for painting on location. A simple hint of texture is all you need. I have simplified these textures by using a glaze (snow on the mountain) and by sandpapering the dry color (for the shimmer at the bottom edge). Use sandpaper on dried color to recover white shimmer. The edge of a razor blade can be used, and the paper must be bone dry. Don't distract from the simple design. Keep details, particularly busy texture, out of your mind while using this technique. An exciting silhouette is enough to create strong character for each plane. Uniform value needs to dominate each plane. Tonal values and color are the elements used to define the shapes. Texture is a dirty word here.

I started with the light wash of the sky, using a soft, ¾-inch (19mm) flat brush. After the wash dried, I painted the most distant pale silhouette of the hills. Again I waited for the paper to dry, then dropped in the nearby shore trees in a darker wash. So far my colors were Burnt Sienna and Ultramarine Blue Deep. Then I charged this wash with a little Aureolin Yellow and Burnt Sienna on the left side. I glazed in the reflecting water and a few hints of waves at the bottom.

Natural texture caused by the sedimentary color setting in the low spots of the paper

Drybrush indicating shimmer

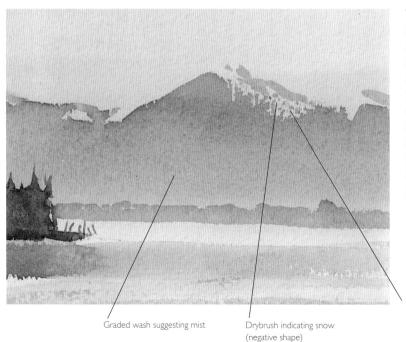

Charged warm

This little sketch was done with only two colors, Ultramarine Blue Deep and Burnt Sienna. I proceeded with the wash of the high mountain range using a soft, ¾-inch (19mm) flat brush fast enough at the top of the wash to skip here and there, creating the illusion of snow. After this dried, I painted the medium-dark strip at the white edge of the river, then the darkest and closest group of trees on the left-hand side as well as the reflecting patterns.

Sandpapered light texture

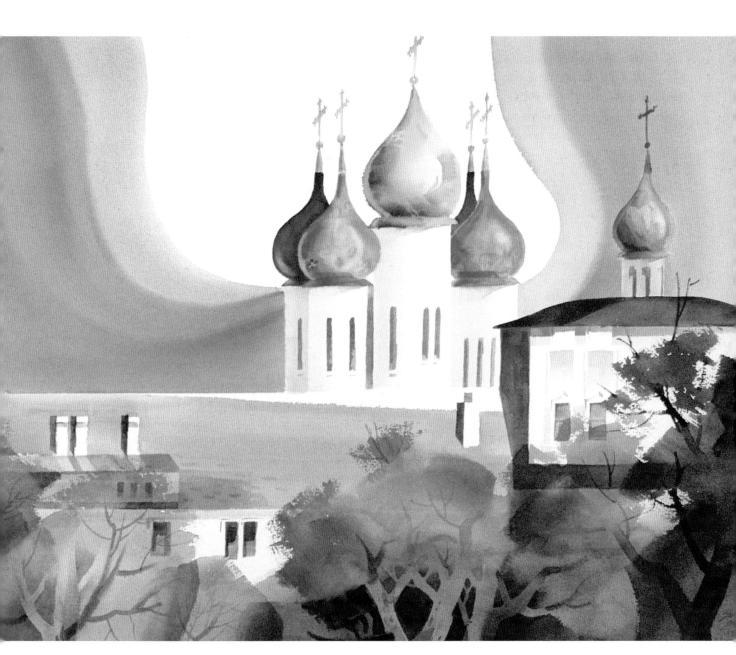

My visit to Russia left a profound impression on me. I was particularly awed by the spiritual qualities of their churches. To communicate this feeling, I repeated the shapes of the onion domes in the background with the color of the sky. I painted the steeples into the white shape left untouched as a contrasting complement. I treated the buildings as if they were behind the foliage of the trees. The translucent foliage allowed a few building details to come through, and the dark foreground leads the viewer to the light background and the contrasting energy of the powerful focal point—the domes.

New Spirit 22" \times 30" (56cm \times 76cm) Collection of the artist

Background Forest

This technique can be used for many background situations. Its success depends on decisiveness. Choose colors that can start off the shape with a very wet, neutral color, establishing the shape's value. Into this wet wash, charge brighter, lighter colors and let the colors mingle freely. Don't help them! The fresh result is your reward for this discipline.

It takes a practiced sense of timing to create this effect. With the corner of a ¾-inch (19mm) flat brush, place a few droplets of water into the drying but still moist dark background color. The tree shapes of the resulting back runs create exciting light impressions that look like frosty shrubs. There's about a 30-second time window, just as the drying paper loses its shine, when this technique works. Bad timing gives a bad outcome.

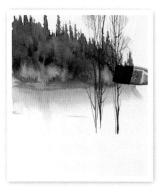

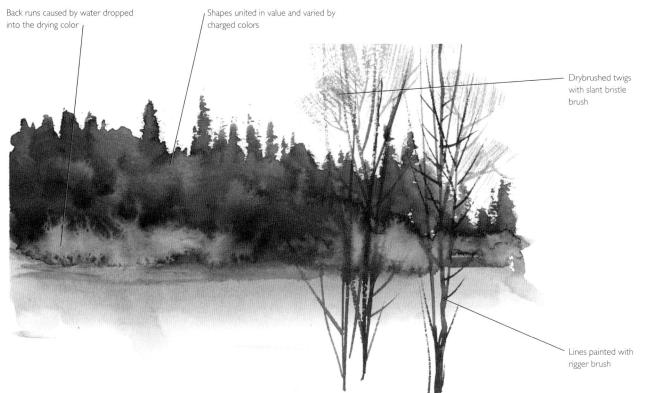

I used Magenta, Cyanine Blue and Cadmium Red Orange to paint the forest shape with a 1½-inch (38mm) slant bristle brush, aggressively changing color dominance, dipping into my palette, as I expanded my wash from left to right. I allowed the left side to remain darker and bluer, turning lighter and warmer on the right. Before the color dried, I placed a few droplets of water at the bottom edge of the wash to indicate frosty shrubs. I also painted in the light blue to indicate icy snow. Total time to this point was about two minutes. After most things were dry, using my rigger I painted the tall trees in the foreground.

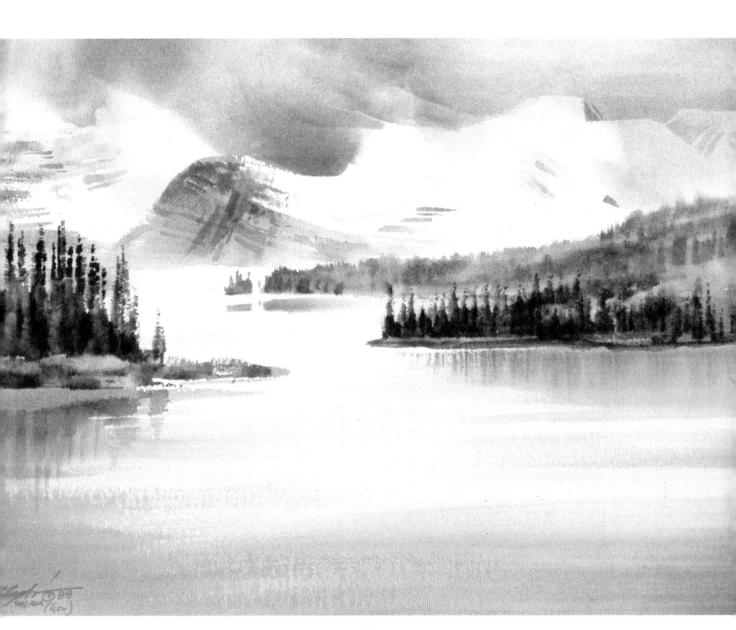

The Canadian Rockies offered this imposing subject. I painted the turbulent clouds wrestling with the snow-covered mountains in the background fast enough to allow some of the washes to wet-blend as they touched. The bright light in the distance is the justification to paint the mountains in warm colors. The middle-ground trees are dominated by dark values. I painted them with the edge of my slant bristle brush held upright. The water in front is medium in value and turquoise in color, typical of silt-influenced lakes of the Rockies. I painted the breezy surface with horizontal brush-strokes fast enough to blend, but here and there a little drybrush became part of the active water's surface.

High Country $14\frac{1}{2}$ " \times 20" (37cm \times 51cm) Collection of the artist

Winter Island

Evergreens can look very exciting when painted with this technique. The flat side of your slant bristle brush must barely touch the dry paper to get the "needle" effect. Too much pressure creates a lump that is not as interesting. Don't hesitate and don't pick, just touch down and go.

In one stroke, you can paint the tapered point of the trees on the wet portion of the background as well as lacy drybrush indicating open foliage over the dry white area. Use a 1½-inch (38mm) slant bristle brush, holding the long-hair end upward and the short-hair end to the bottom of the trees. The brush is loaded with dark color and held at about a 45-degree slant as you lightly touch the paper, creating the tall evergreen shapes.

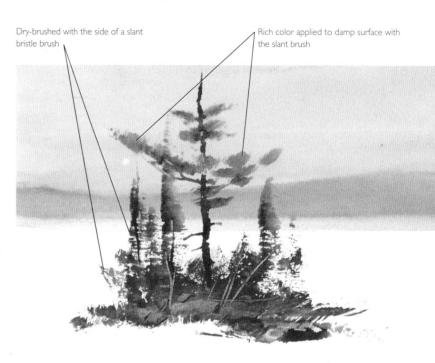

For the lower foliage, hold the edge of the brush sideways and on a vertical angle. I masked out the distant shore with masking tape, then painted the deep sky and the darker background hills using Phthalo Green and Magenta. After removing the tape, I painted the graded wash at the base with the same colors in light value, using a 1-inch (25mm) soft slant brush held long-hair end down so the top edge was lost. With a very dark combination of Phthalo Green, Magenta and Cadmium Red-Orange, I pressed my slant bristle brush very gently to form the lacy drybrush where the white paper was bone dry. The same color softened against the still-moist background. I played with the bottom edge of the island, heavily pressing my brush to release the dark colors with varying color dominance. While this color was stil moist, I knifed out a few lighter rock and weed shapes.

Rolling Snowbanks

If there is a single brushstroke in watercolor that could be considered the most important, it's the lost-and-found edge. This tricky little fellow can be used in virtually any subject. The sharp edge of the stroke or shape represents dry-paper technique, while the blended edge belongs to the wet-in-wet technique. Practice this brushstroke until you have it under control.

Apply a wet blue brushstroke with a ¾-inch (19mm) soft flat brush. To lose the top edge of the bottom light blue brushstroke, touch the color with the long-hair end of a thirsty 1-inch (25mm) slant brush. This soaks up some of the color as it moves sideways. Hold the brush at a 45-degree angle and press it just hard enough to bend the hairs somewhat.

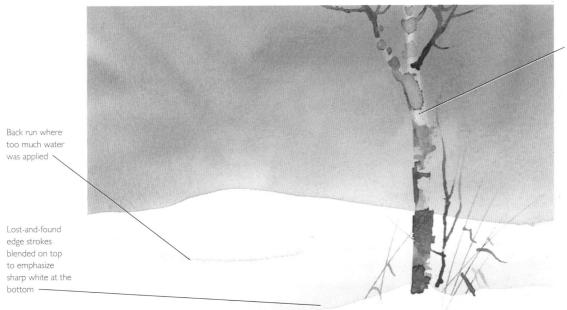

Wet-lifted color after background dried

Wherever you see a dip in the snow, the front (bottom) edge of the stroke is sharp, defining the white high spot of the snowbank in front of it. I applied the wash on dry paper (to get a sharp edge) with a ¾-inch (19mm) soft flat brush. Immediately I switched to a barely moist 1-inch (25mm) slant bristle brush and, letting its long-hair point touch the wet paint, I blended the top side. The brush needs to moisten the paper next to the brushstroke and soak up some of the color simultaneously, allow-ing the remaining paint to spread into the moist area and to disappear into nothing. Just below the high snowbank at the horizon is a dip where I used too much water in my blending brush and a hard back run happened.

Ice on Trees

Timing is very important for this little exercise. Just as the dark background wash loses its shine, go as fast as you can with a little water in your small rigger and paint the frosty branches. Think of the general shape of the trees, not the branches. You have only about twenty-five seconds to paint the frosty branches on a sketch like this one. Poking at it after the paint has dried won't help you. Catch it fast when the time is right, then walk away.

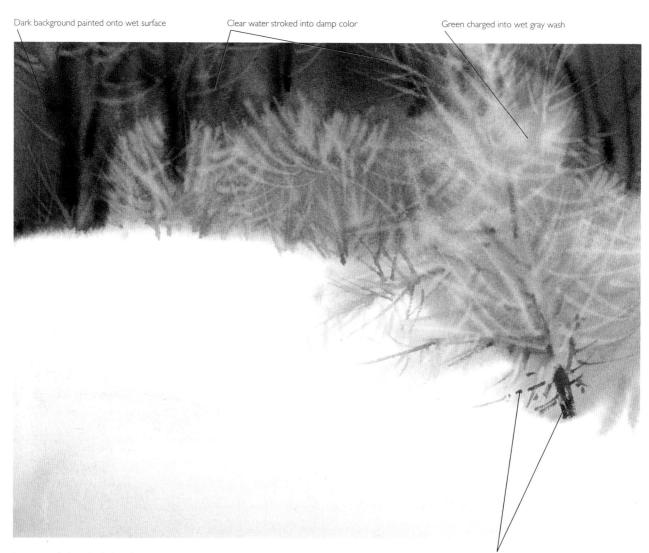

I painted the dark background onto a wet surface using Magenta and Phthalo Green, which promptly neutralized each other. As the wash began to lose its shine, I painted in the ice-covered branches. I used my small rigger and applied clear water in a fast repetitive way, creating rhythmical branch shapes. In the lower right, where the branches reach the white snow, I switched to a little of the combined colors in my rigger and continued painting the pale gray frosty branches against the still-moist white background. After the paper dried, I slipped in the few sharper dark branches at the base of the closest tree. Darks painted after background has dried

Frost on Trees

Controlled back runs are a very effective but seldom used extension of the wet-into-wet watercolor painting style. Use them to loosen up your paintings. Feeling is your only guide for these very free shapes. The fast application and the timing are so crucial that you watch the evolution of the tree shapes while you build the back runs with water droplets.

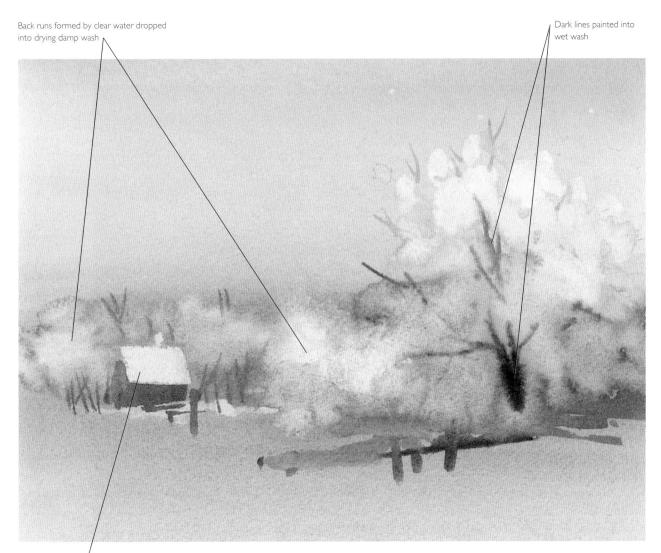

Lifted white shape

I chose Cerulean Blue, Ultramarine Blue Deep, Gold Ochre and Burnt Sienna for this study. I painted the whole surface on wet paper starting at the top with Cerulean Blue. I continued by adding a little Gold Ochre to the lower sky and followed with a heavy wash of Ultramarine Blue Deep and Burnt Sienna, blended a bit lighter as I spread the wash downward to the bottom edge of the paper. After about a minute, the wash started to dry, so I dribbled little droplets of clear water with my rigger, creating the frosty-looking back runs. I also painted a few tree trunks, branches, and the distant log cabin into the almost dry shapes to give the scene a little sense of reality. I removed the white snow on the roof with the wet-and-blot technique after everything had dried.

Setting Sun

When painting a sunset (or a sunrise) remember that nothing can be lighter than the light source—the sun. The trickiest parts of the sketch below are the hot-color charges in the tree trunks near the bright sun. The dark, cool wash of the tree must be charged with a warm color while it is wet. Cadmium Orange is the hottest color in this sketch. The charged color is applied generously to look right even after the color dries. Keep the hue and values consistent.

> Dark foliage drybrushed onto dry surface

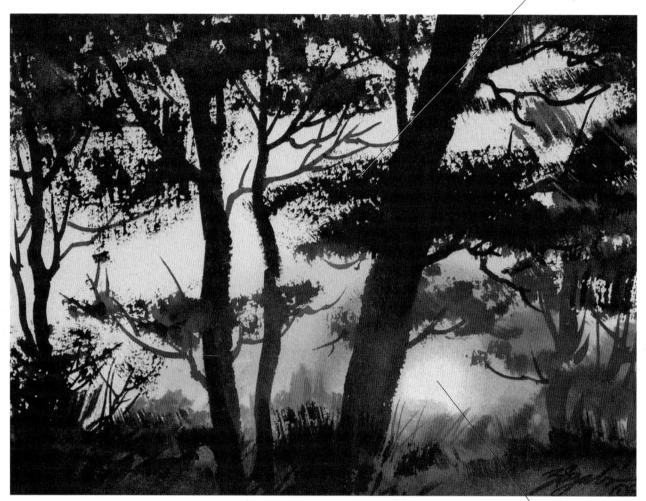

I started this by painting the background onto a wet surface. I began with Ultramarine Blue Deep at the top. I moved my 1-inch (25mm) soft slant brush with a curving motion around the sun's circular shape. For the sun, I dropped in a heavy splash of Gamboge Yellow and surrounded it with glowing Cadmium Red Orange. All these washes blended into each other.

The warm, dark foreground came from a mix of Phthalo Green, Rose Lake and a bit of Cadmium Red Orange. As the color was drying, I lifted out much of the Gamboge Yellow and the light color of the sun resulted. My lightest value was established. After the paper dried, I applied the very dark silhouette of the trees' foliage with the flat side of a heavily loaded 2-inch (51mm) slant bristle brush, lightly touching the dry paper. I charged the wet washes near the sun, as well as the reddish brown middle-ground trees on the right side, with a lot of Cadmium Red Orange. The result is hot color dominance and very high value contrast.

Wet-lifted sun

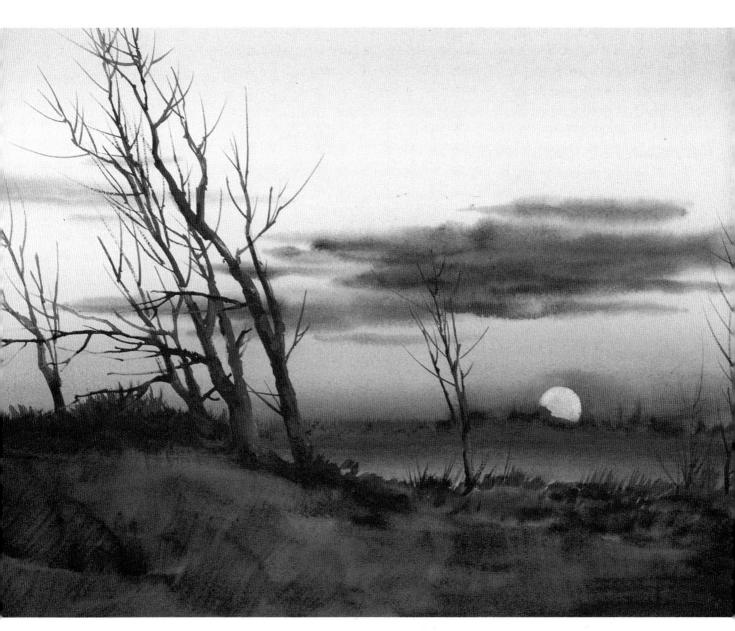

Close to where I planned the sun's location, I charged the dark, wet foreground wash with Cadmium Yellow Pale, Cadmium Orange and some Magenta to echo the powerful light of my light source. When that was dry, I masked out a circle shape, and with the 1-inch (25mm) slant brush loaded with clear water, I scrubbed off the color and blotted it into a paper tissue exposing the light shape of the sun. Because the color looked a little too white, I tinted it with a bit of warm yellow color.

The Last Wink

 $13\frac{3}{1} \times 18$ " (35cm × 46cm) Noblesse cold-pressed paper Collection of Ruth and Jack Richeson

Negative Shapes

Charged colors with drybrush

Negative shapes are the shapes that are left after we paint around them. Negative shapes stay white if the paper is white. If the surface has a light color on it, the negative shape will show that color. The background next to the negative shape is actively painted and the light shape is left out. The color that defines the negative shape must be darker than the shape it surrounds. A good rule is to think of the negative shape's design while you are painting the positive brushstrokes.

Negative shapes defined by dark

wash next to them

Isolated color attracts the eye

Reflection of negative shapes

To give the white trees a sharp edge, I painted the background and the water simultaneously around the shape of the tree and its reflection. My wet washes were highly charged with different dominant colors. I used a $1\frac{1}{2}$ -inch (38mm) soft slant brush with Cadmium Red Orange, Magenta and Gamboge Yellow. I glazed the ripples after the wash of the water had dried. The isolated burst of Cadmium Red Orange next to the white tree attracts extra attention to the center of interest.

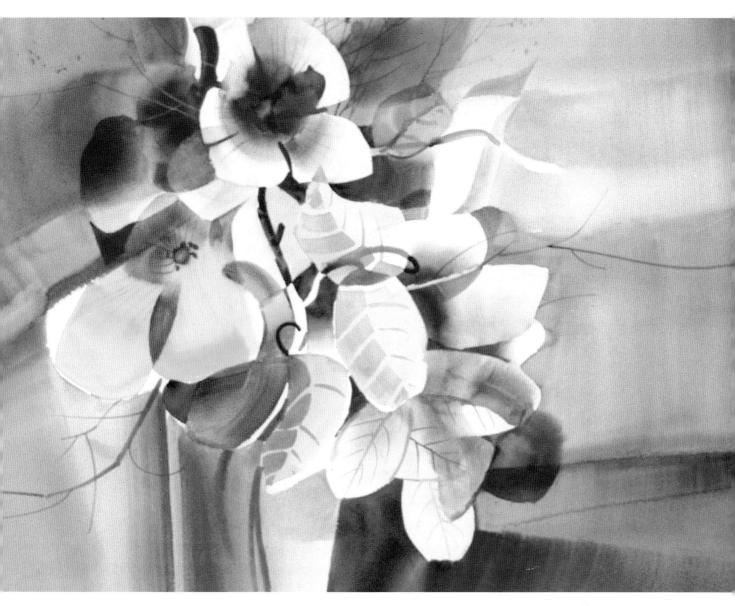

This stylized flower impression is an expression of bouncy colors complemented by a calmer and more neutral background. I first established the approximate colors and shapes of the group of flowers. I treated them as curvilinear negative shapes while I painted the background around them. I allowed the background shapes to softly blend as they touched. I also took advantage of the staining nature of my Cyanine Blue and separated the other colors from it, exposing an occasional clear blue stain. One of these is clearly visible in the background to the left of the yellow petals and at the bottom center to the right of the white petal. The happy color impression suggested the title.

Birthday Wish 22" × 30" (56cm × 76cm) Collection of Douglas de Vries

Charged Washes

For this approach, your silhouette color (here, indicating a church) establishes the value of the shape. You must apply the charging colors, particularly when light pigments are replacing dark ones, with lots of water and paint in your brush and on the paper. You may have to repeat the charging four or five times, so use very rich, liquid color each time you touch the wash. Remember—everything must be dripping wet.

As soon as the dark silhouette of the building is painted, charge the still very wet wash with a very wet brush full of yellow pigment. Repeat this move several times, wiping the brush clean with a tissue between each application. When the dark color is completely replaced by the yellow, let all the colors dry.

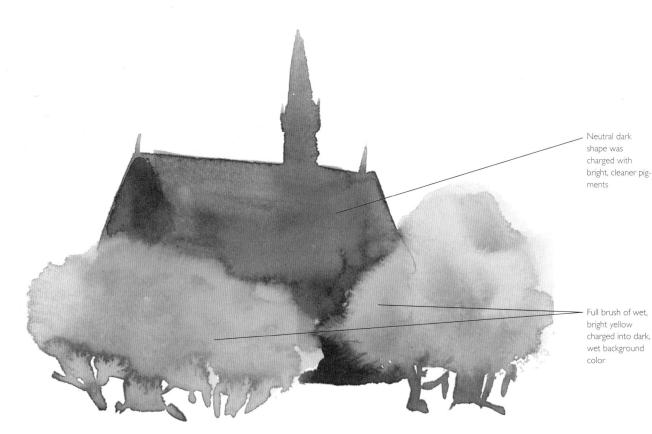

I started with a dark neutral silhouette of the building's shape. My colors were Phthalo Green, Magenta and Gamboge Yellow. While this shape was very wet, I charged in the bright yellow trees, removing the dark corners of the building and replacing them with the yellow hue. Even a dark staining color, freshly applied and wet, can be replaced by another strong, wet mixture with a few repeated applications. The yellow foliage was also charged with a little Magenta.

Colorful Darks

Dark washes tend to be boring if they are colorless. To make them more interesting, wet-charge them with other colors. Keep the value range of the charged colors close enough to the original wash in order not to change the light condition drastically. Remember, this is a wet technique. Both the wash and the charging color in your brush must be very wet.

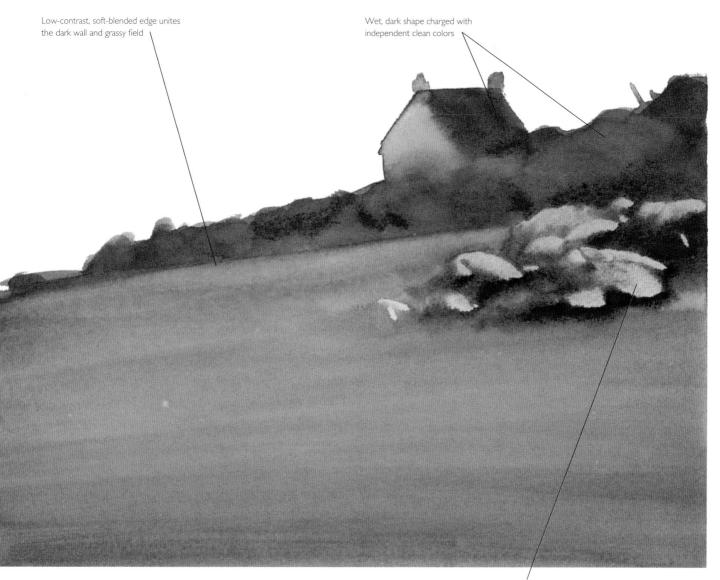

This simple hillside study is painted with Phthalo Green, Rose Lake, Magenta and Gamboge Yellow. I started by painting the shape of the house and foliage in a medium value mixed out of all four colors, using a ¾-inch (19mm) soft flat brush. While this wash was still wet, I charged individual colors into the wash, allowing them to dominate local areas. Next, I painted the green hillside, dominating the mixture with Gamboge Yellow. Before the paper was dry, I dropped in the dark background color for the rock pile and knifed out the light top of the rocks with the heavily pressed heel of the palette knife. The uninterrupted medium and dark values suggest a strong unity in the sketch.

Light shapes lifted from wet surface with a palette knife

Smooth Tree Bark

Here are some more opportunities to use your palette knife, but for this technique to work properly, don't paint your color too wet. The wash must be tacky and barely moist as you apply it. The knifing must take place immediately, particularly for the fine texture. If the color is too wet, it will stain the paper by the time it dries enough to be in a workable condition, and it will look messy. If you knife the color while it's too wet, the knife stroke will actually go dark because the wet paint will creep back into the knifed area. Do it right the first time—apply your color with very little water.

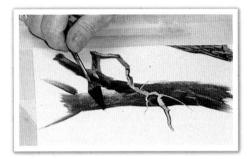

To achieve the bark texture, scrape off the damp color, holding the palette knife firmly by the handle. The thumb transfers the necessary pressure from the wrist. The scraping edge of the knife is held at a 35-degree angle and pressed a little harder at the widest part, creating the lightest lifted value. As you lift the blade toward its point, the gradually reduced pressure results in the bark texture as the value changes.

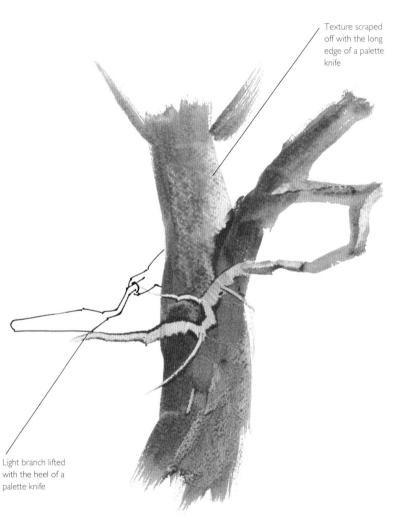

I started this study by painting the shape of the tree trunk with a 1½inch (38mm) slant bristle brush filled with a rich consistency of Winsor & Newton Sepia. As soon as I put my brush down, I lifted out the texture with my palette knife. I held it pointing to the left, with the edge of the knife pressing hard at the wide part (heel) and releasing the pressure toward the tip. I moved the knife downward and the texture is the result. While the color was still set, I painted the limbs. Where the curving branch bends in front of the trunk, I extended the shape by knifing out the light branch, pressing hard on the heel of the knife.

Rough Tree Bark

To create this texture, the base color must feel tacky, not too wet. The knife doesn't need to be pressed too hard if the consistency of your color is right. If the wash is too wet, the knife strokes will go dark as the watery wash gushes back into them. Be confident when you press the knife's heel, though great pressure is not required. Remember you are painting sharp light shapes into a damp color. The condition of your wash must be just right.

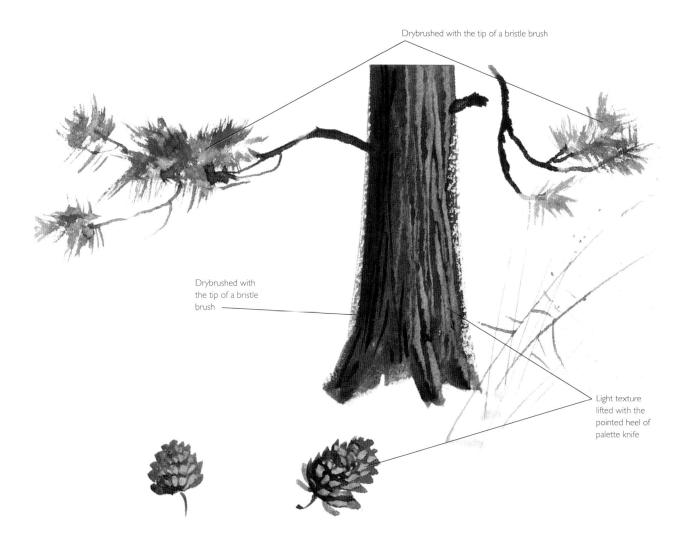

The rough bark texture started with a quickly applied shape brushed on with a $1\frac{1}{2}$ -inch (38mm) slant bristle brush. My colors were Burnt Sienna and Phthalo Blue. Just as soon as I was finished and while the color was still fresh, I knifed off the light texture by stroking back and forth with the heel of my palette knife. I moved the knife up and down, tilting the blade back and forth as if I were sharpening a straight razor on a leather strap.

My technique was similar on the pinecones but I used short, repetitive strokes for the light shapes. I drybrushed the foliage clusters with the tip of my slant bristle brush in the direction the needles grow.

Glazed Tree Bark

Here, the neutral tree trunk shape is painted with semi-complementary colors that make it less monotonous. The colors charge the gray wash and add a colorful influence. For this approach to be truly effective, the wet-into-wet technique must be used.

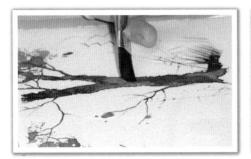

For the relatively small shape of this tree, apply the charging colors with a ¾-inch (19mm) flat, soft aquarelle brush. Use the corner of the brush with gentle pressure to drop the pure colors into the wet shape of the tree. Timing is crucial. Act while the first wash is still very wet.

For the delicate weeds, hold the palette knife upright and cut a line into the paper, pressing the tip and releasing a small amount of wet color into the groove simultaneously. The high angle is important to allow gravity to help in freeing the wet color.

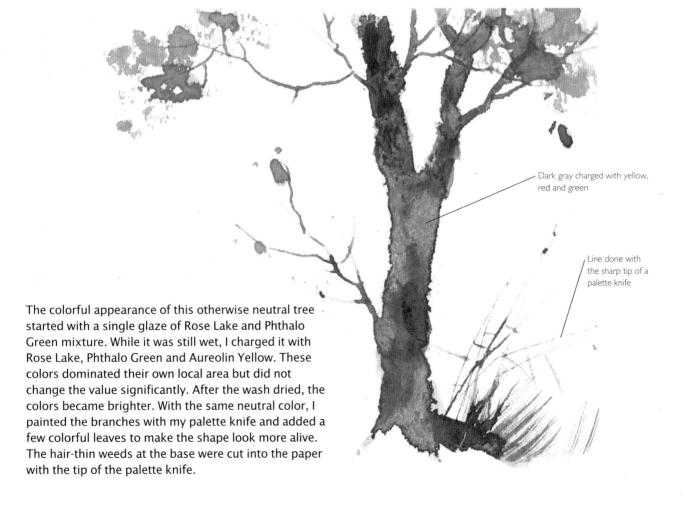

Tree Impressions

With the same brushstroke you can make very different tree impressions depending on whether the paper is wet or dry. The clear water approach requires dark, wet colors and very careful timing to hit the paint just as it loses its shine. On dry paper, apply your brushstrokes with very light pressure. The weight of the brush is almost enough. On a wet medium- to dark-value wash, tree impressions can be made by brushing the damp paper with a small flat bristle brush or by scraping with a brush handle.

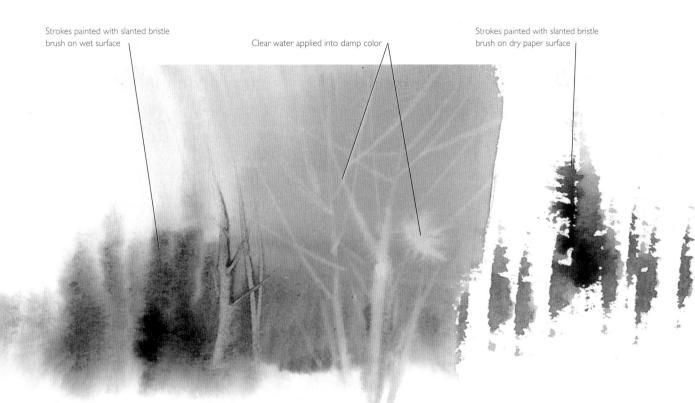

Clear Water

Using Cyanine Blue and Winsor & Newton Sepia, I painted a hint of a forest-like setting on wet paper with a 2-inch (51mm) slant bristle brush. The brush was not too wet, so it stacked up water and deposited the colors simultaneously.

Wet Wash

Just after the drying color lost its shine, I brushed in the shape of the light tree fast enough to keep the spreading light shape from running out of control. At the dark section of the background, I removed the light tree shapes with the tip of my slanted plastic brush handle.

Dry Paper

On dry paper I held the 2-inch (51mm) slant bristle brush flat so that the handle was parallel with the paper and the narrow end was at the top of the evergreen. The edge of the hair was lined up with the potential location of the tree trunk. As I touched the paper, half of the evergreen shape emerged. To do the other half, I flipped the brush to its other side and repeated the stroke.

Rock Setting

A very important part of this technique is to charge the otherwise dark base wash with pure staining colors. These will stain the paper, and after you knife out the shapes of the rocks, they will show these dominant hues in lighter value, making them sparkle with color. Staining colors are the key here.

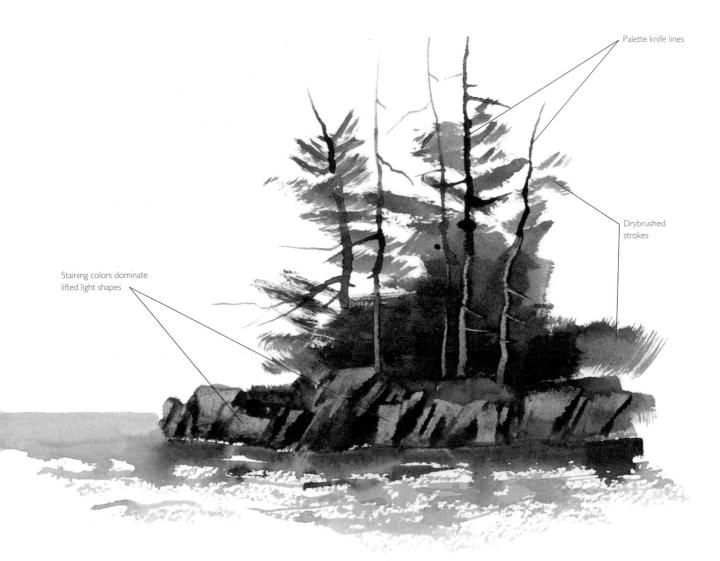

First, I painted the foliage of the pine clump using Rose Lake, Burnt Sienna, Cyanine Blue and Phthalo Green in varied dominance. From this very dark, wet shape, I knifed out the light tree trunks and branches. Then I painted the dark part of the tree trunks with a small rigger. To paint the rocky foreground, I added dark colors strongly dominated by individual hues at different areas. With the firm heel of my palette knife, I squeezed off the slab-like shapes of the rocks. The color dominance became even more evident in these lighter shapes. I glazed the water, drybrushing the lower edge to hint at sparkling waves.

Palette Knife Trees

You must use very liquid paint for this technique. The paint must flow off the knife the same way it flows out of a brush. When you paint the branches, hold the knife lightly and drag it with a light pressure against its tip, without lifting it, until it runs out of paint. This technique also can be used for exciting abstract background texture, particularly if you crisscross your shapes or apply different colors for different strokes. Don't limit this or any other technique to only one subject. Expand on it by using your imagination.

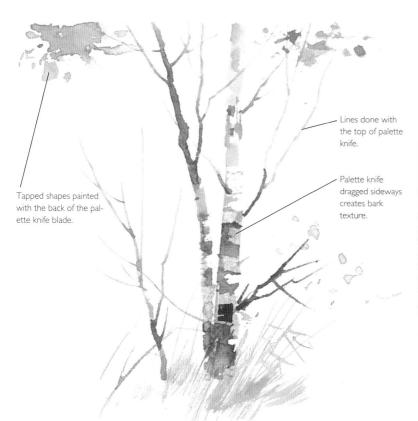

My colors were Cyanine Blue, Rose Lake and Aureolin Yellow. I painted these trees entirely with my palette knife. For the trunk I used a little liquid paint on my knife's edge and dragged it from one side of the trunk to the other. Where the color is textured, I left it alone. Where it was too solid, I knifed out a lighter strip. I repeated this process varying my colors a little. With a dark liquid mix on the palette knife, I painted the branches and the young sapling. I even tapped on a few leaves with the back of my knife point. "Tapping" is touching the paper repeatedly with the back of the knife blade to which the liquid paint is applied. The delicate, tall weeds were cut into the paper with the edge of the knife tip covered with a little liquid paint. The small drybrushed grass cluster at the tree's base was the only part done with a brush.

For the loose birch bark effect, dip the palette knife in wet color. While holding it at a low angle, touch the edge on the dry paper to make a horizontal dragging stroke. Where the color comes off as a solid wet shape, knife off the light sections immediately with the firmly pressed heel of the blade. The knife's response is unpredictable; be prepared to add or remove color as required.

The position and angle of the palette knife is important as you paint the branches. The liquid paint rushes off the blade if it is held on a very high angle, while its flow slows down if the blade is held flatter. Drag the knife's tip away from the trunk to allow the branches to taper toward their point.

Brush Handle Trees

For this technique, use a brush that has a slanted acrylic tip at the end of the handle. For a larger painting, try using some other firm tool, such as a credit card. The important thing is to watch the condition of your wet color: don't use it too wet or too dry. If you use a 300-lb. (640gsm) paper for a larger painting, it will stay moist a little longer, giving you additional time to maneuver a little more complex design with this lifting method. For narrow shapes, I still recommend the use of the slanted tip of your plastic brush handle.

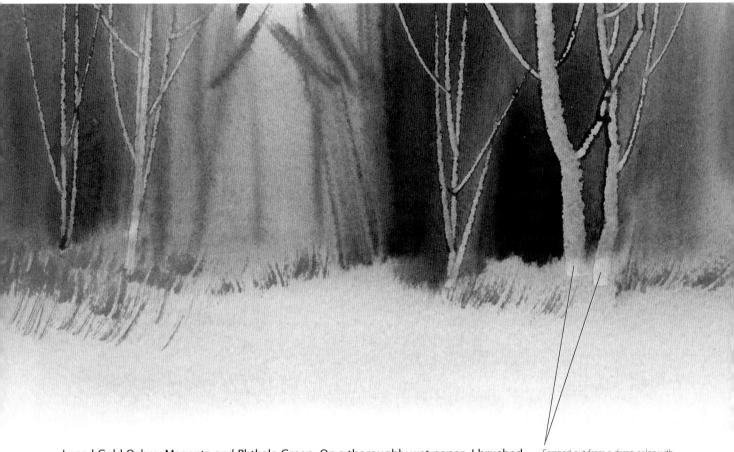

I used Gold Ochre, Magenta and Phthalo Green. On a thoroughly wet paper, I brushed in the tone and silhouette of the forest with a 2-inch (51mm) slant bristle brush filled with lots of paint and just a little water. Where individual dark trees appear, I used only the tip of the brush. When I stopped painting, the paper was barely moist and just right for scraping out the light trees. I held the slanted tip of my acrylic brush handle slightly sideways for the widest tree. Then, with very firm pressure I scraped off the color. Even movement was essential for a successful shape. For the thinner branches, I held the brush handle on a higher angle. Because the ideal moist condition doesn't last long, timing is crucial. This scraping, for example, took only a few seconds. The drybrush grasses were applied for variety. Scraped out from a damp color with the tip of the slanted end on an acrylic brush handle

Soft Lifted Trees

This technique is a lot of fun. The ideal condition of the paper is between very wet and dry. For the dark soft shapes, use much less water in the brush than there is on the paper. For the light shapes, a controlled small amount of clear water in your small brush painted into the damp color brings a very exciting result. If you should be a little late and the water is not spreading, let it sit for half a minute to loosen the pigment. Then blot it by pressing a tissue over the shape. Chances are that you will get your light lines anyway.

Color-charged medium-dark background

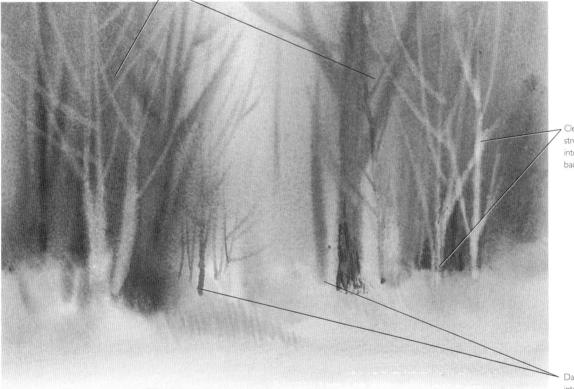

Clear water strokes painted into drying damp background

 Dark lines painted into damp color

After I wet the paper completely, I painted the dark tones of the forest with a rich mix of Burnt Sienna and Cobalt Blue. After the larger shapes looked good, I painted the ground with a Gold Ochre dominance in a rich wash made from all three colors. At this point, I mixed a very dark combination of Burnt Sienna and Cobalt Blue, dominated by Burnt Sienna, and painted the darker trees with the tip of the brush. As the wash was losing its shine, I lifted out the wide lighter tree with a ¾-inch (19mm) flat aquarelle brush in a damp but thirsty condition. Then I switched to a no. 5 rigger and defined the light trees and branches by introducing a little water from the tip of my rapidly moving brush. Because the wet condition held, I sketched in the blurry but clearly readable young trees in the center region with a rich mixture of blue-gray in my rigger.

Wet-into-Wet Evergreens

Wet-into-wet watercolor is a technique so versatile that it can be used on any paper with any tool and with any brand of watercolor, but you must keep an important point in mind to succeed with it easily. However wet your paper is, always keep less water in your brush than there is in the paper. When they touch, the water unites. With too much water in your brush, you've got a gushing back run. Not enough, you have a lump or a smear. A firm bristle brush (like my slant bristle) has just the right temperament for wet-into-wet painting. To reduce water in your brush, blot it on a paper pad.

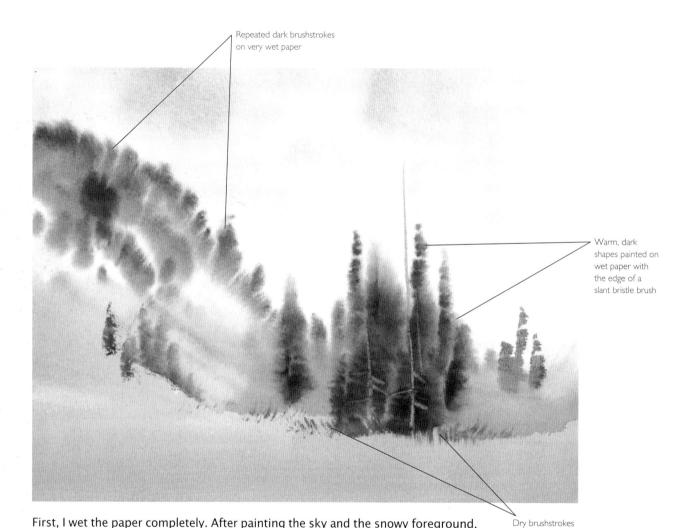

on dry surface

106 Download free wallpapers at artistsnetwork.com/zoltan-szabo

branches.

I painted the background trees in a curving line indicating a hill. For these rapidly applied, rhythmical shapes, I used my 2-inch (51mm) slant bristle brush held with its long-hair tip pointing downwards, teaming with a rich mix of Burnt Sienna and Cobalt Blue. The moisture on the surface blurred the shapes into a soft, drifting mood. Without picking up more water, I filled my brush with darker color and firmly touched the wet surface with the edge of the brush. Again, I held the long hair near the bottom of the tree shapes where they are naturally wider; the shorter hair painted the tree trunks and

Sunlit Mountain Tops

Just a little warning: when you paint subjects like this one where the color needs to be flawlessly clean, use a very clean brush, fresh color and unpolluted mixing water. Dirt in any of them can jeopardize the brilliance of the necessary colors. The drama is the result of the contrast between very intense light colors and very subtle dark colors next to each other.

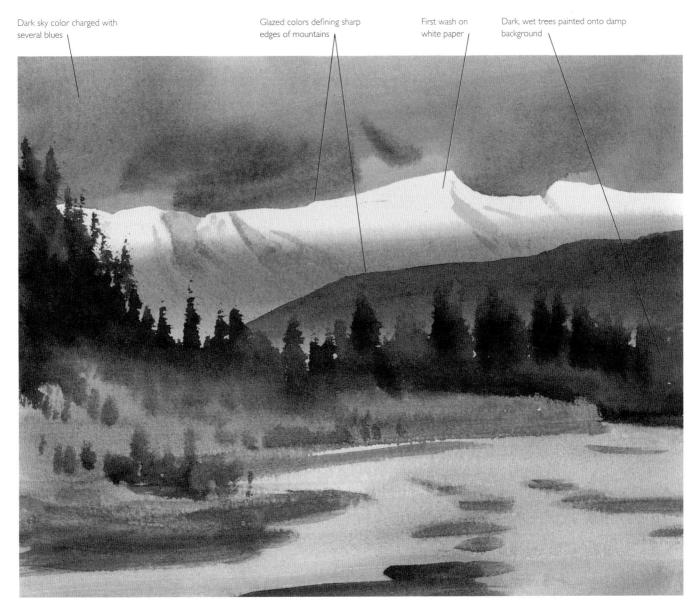

My palette was the most important component of this study. The sunlit top of the distant mountain and its reflection were painted with a light wash of Rose Lake and Gamboge Yellow. The shaded portions were glazed with two dark layers of Magenta, Phthalo Green, and Rose Lake in varied dominance.

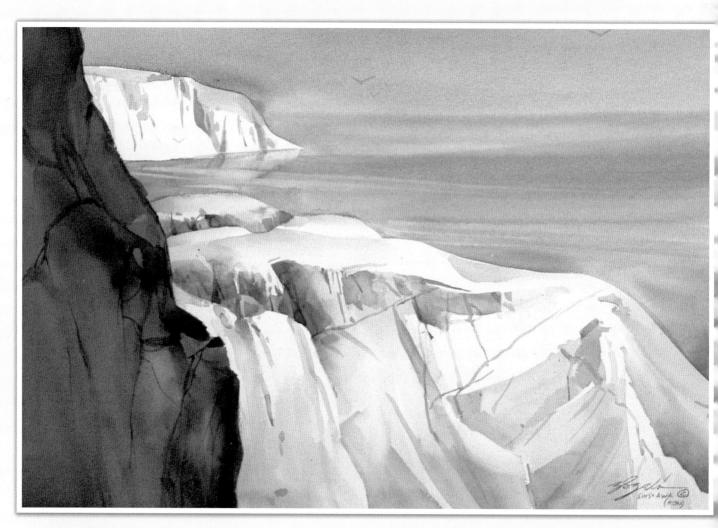

Light & Shade 13½" ×17½" (34cm × 44cm) Collection of the artist

6

Painting Demonstrations: A Step-by-Step Gallery

want to bring all the pieces together and show you how some of the techniques shown earlier in the book can be used in finished paintings. Remember that all of the techniques illustrated in chapter 5 can be used in many ways other than those shown. Be creative in how you apply what you have learned.

All the demonstrations were done with Maimeri watercolors. I used only the colors that are on my selected palette illustrated in chapter 1, but keep in mind that some color names may have changed or been discontinued. Step-By-Step

Flowers Glazing with Staining Colors

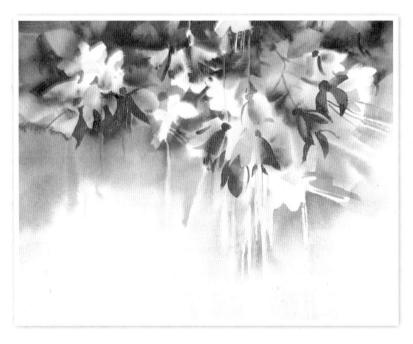

1 started by wetting my paper, then flowed in the colors of my future flower clusters with Verzino Violet and Crimson Lake. Around these soft reddish shapes, I left lots of white negative spaces by painting around them with the cool, mediumvalue background. My colors varied from Cyan Blue to Turquoise Green, Permanent Green Light to Permanent Yellow Deep. My blues and greens and Crimson Lake are staining colors, so I made sure they were in a good spot because they couldn't be removed after they dried.

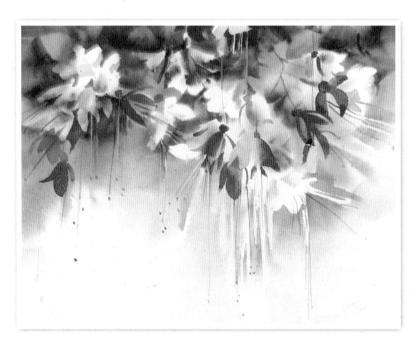

2 After the paper dried, I glazed some of the luminous, richly colored, darker background shapes, carefully leaving out many negative contours of the flower clusters. I continued with more glazed details, expanding my positive shapes. Against the light background, I painted a few shaded purple flower silhouettes. I painted the drooping stamens with my small rigger brush, which is designed to do long, thin lines exactly like these delicate calligraphic strokes.

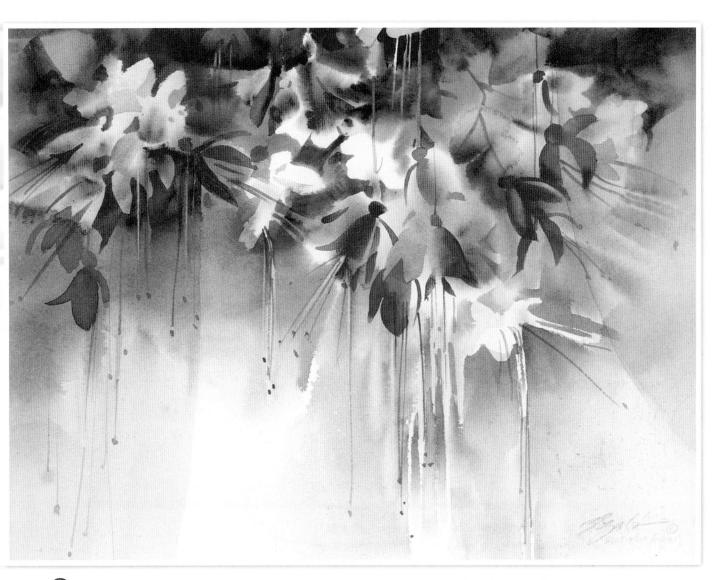

B To balance the composition, I needed large subtle shapes. So I glazed a pale neutral mix of Phthalo Green and Verzino Violet on both sides of the painting. The curving edges echo the other curvilinear shapes, but the gentle tone reduced the overwhelming strength of the white at the bottom edge. The largest flower cluster became the center of interest with a lot of visual energy concentrated in it because of the highest contrast there.

Bells of Love 13¾" × 18" (35cm × 46cm) Noblesse cold-pressed paper Collection of Dr. Jane O'Ban Walpole Step-By-Step

Icy Creek Glazing and Lifting

1 First, I raised the top of my paper up about one inch (2.5cm) so it wasn't sitting flat. Then I started at the top edge of my dry paper using my 2-inch (51cm) slant bristle brush loaded with a pale mix of Cobalt Blue and Burnt Sienna, varying the two colors' dominance. Using the same two colors plus a touch of Magenta, I established the silhouette of the creek. I started at the top and carried the beading wet wash downward as fast as I could, gradually changing from a darker blue to a lighter, warmer tone. With this positive shape, I not only designed the creek but determined the edges of the neighboring negative shapes of the snow-covered land.

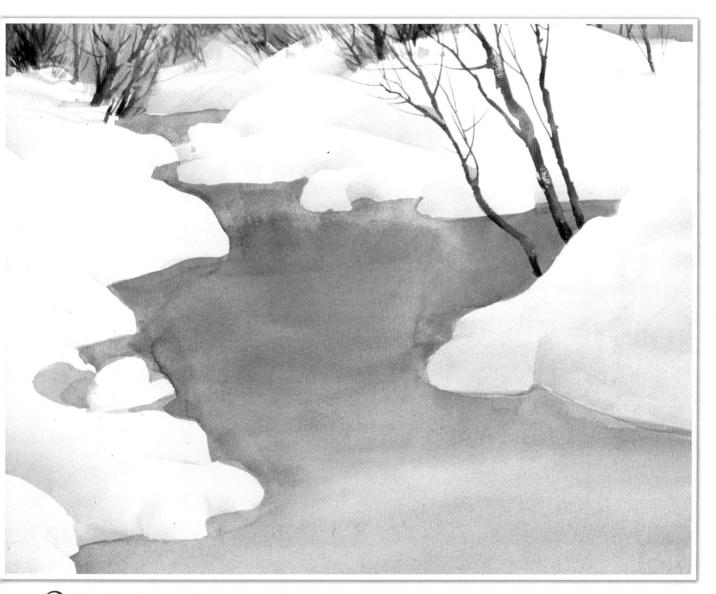

2 The rolling humps of snow were defined with shaded washes by leaving the peaks of each mound pure white and gently shading their near side. To define these white edges, I painted them with a rich mix of Cobalt Blue and Burnt Sienna and immediately blended away the top edges with a thirsty 1-inch (25mm) slant bristle brush. After these washes dried, I glazed in the distant shrubs and trees with a combination of Cadmium Yellow Lemon, Burnt Sienna and Magenta.

To add the closer trees, I lifted out the background of the trees from the dark blue creek shape to allow the warm color to shine with clear brilliance. I used the same colors as before, but painted the wider trunks with the aquarelle brush and the thin branches with my rigger.

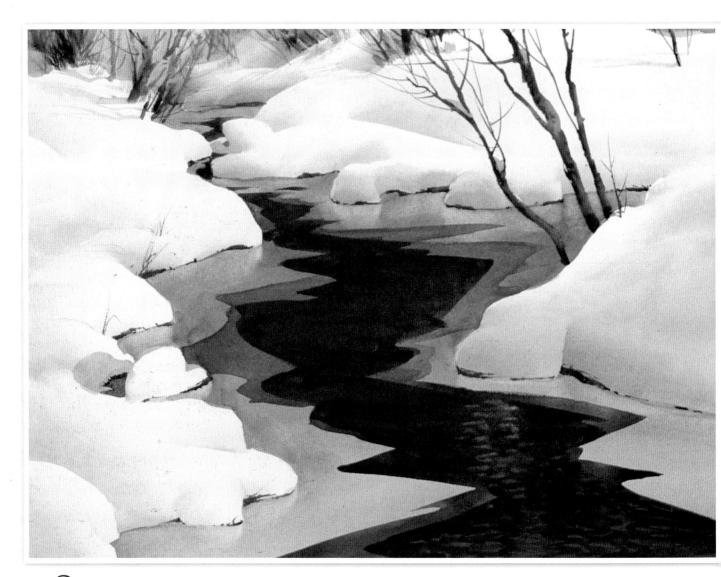

3 To show the ice forming along the edges of the creek, I glazed in slightly darker values of Burnt Sienna, Cobalt Blue and some Phthalo Green. This glaze was dominated by the cool colors in the distance and by Burnt Sienna near the bottom. After it dried, I painted the dark water in the center of the creek with a rich liquid glaze of Burnt Sienna, Phthalo Green and Magenta, then lifted out the reflecting shimmer of the waves using the wet-and-blot technique.

The last detail was the reflections of the snowbanks in the ice. I moistened the shape of the reflection, loosened the pigment with my aquarelle brush, and blotted off the released color with a tissue.

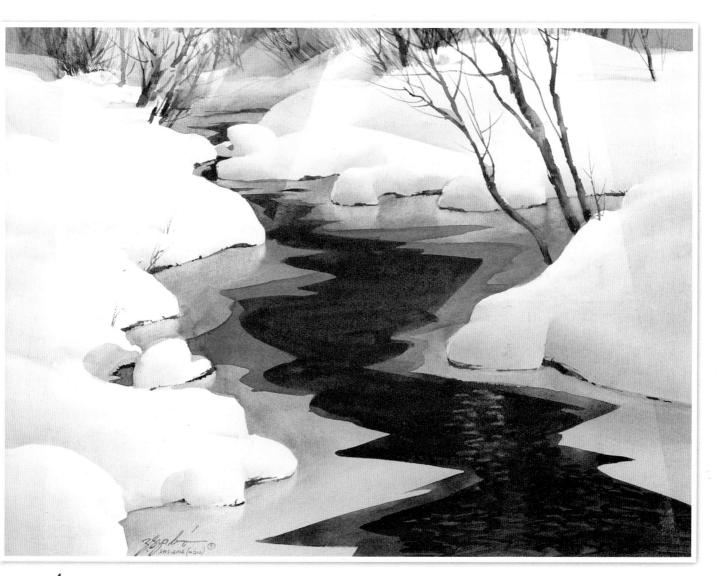

A Because of the overwhelming dominance of curvilinear shapes, and as a complement to the energetic rhythm they represent, I wanted to add a stabilizing effect to the painting. I glazed a few pale shapes with my soft slant brush right over the completed details. I made sure that my color was extremely transparent by using Phthalo Green and Magenta (two extremely transparent colors) heavily diluted with water. Because of the runny condition of my color, I painted the shapes in only one careful pass. This last step also had the effect of strengthening the brilliant white of the snow.

Frozen Assets

13¼" × 18" (34cm × 46cm) Noblesse cold-pressed paper Collection of Drs. Jack and Teresa Flippo

Step-By-Step

Shadows on Wood Staining Texture and Lifted Sunlight

On a dry surface, I masked out each board to allow individual designs to develop. I filled my 2-inch (51cm) slant bristle brush with a mix of Turquoise Green and Ivory Black because of their strong staining quality. I painted a dry brushstroke through the length of my boards, one at a time. This dark line pattern was enhanced to look more like wood grain by using a round Essex brush and a rigger. The calligraphic patterns were united with a dark line between the boards. I added a staining green color of hinted moss with Permanent Green Light and Turquoise Green.

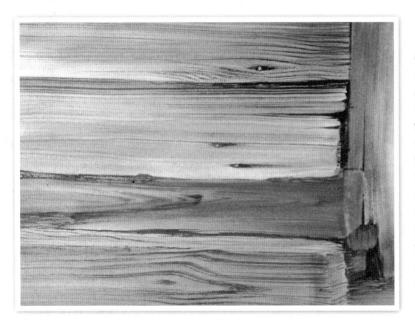

With my 2-inch (51cm) soft slant brush, I glazed the shadow color over the entire area. My color combination was Burnt Sienna, Raw Sienna and Ultramarine Blue in similar value but differing in color dominance. A word of caution: The wash was dominated by Ultramarine Deep, a reflective color. Reflective colors alone or in a mix dry even lighter than do the more transparent pigments. Make sure that you paint them darker than what seems right while the wash is wet, in order to end up with good contrast between sunlight and shadow.

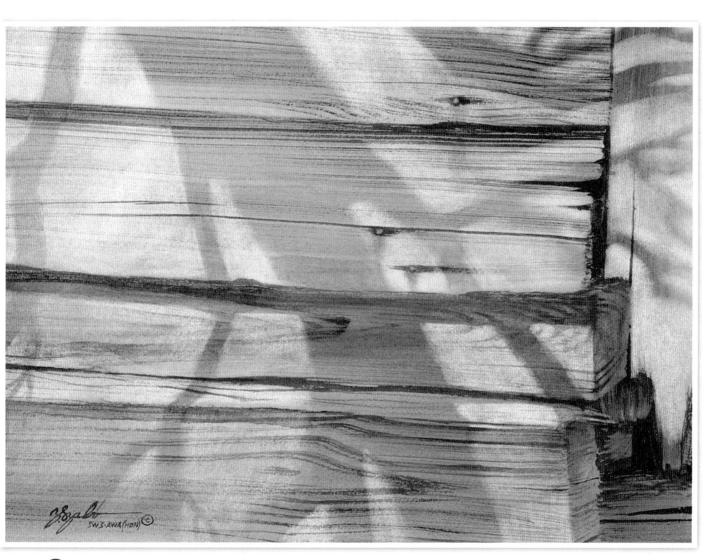

B It was time to lift out the patterns of sunlight. Using my small bristle brush loaded with clean water, I loosened the color on a small area next to the shadow, then blotted with a clean tissue. (It is very important to keep changing tissues between lifting. Freshly lifted color can be pressed into the paper if you try to blot out a scrubbed color with a dirty tissue.) After the sunlight was lifted out and the shadow was established, with my rigger I repainted the dark cracks wherever they were scrubbed off. I also moistened the area next to the nails and dropped in a soft Burnt Sienna brushstroke to indicate rust stains on the wood.

Bowing Shadow

13¾" × 18" (35cm × 46cm) Noblesse cold-pressed paper Collection of Scott and Cindy Parker

Step-By-Step

Autumn Colors Controlling Edges

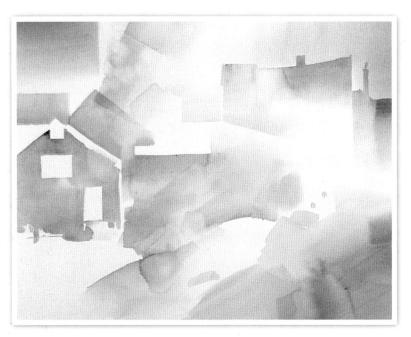

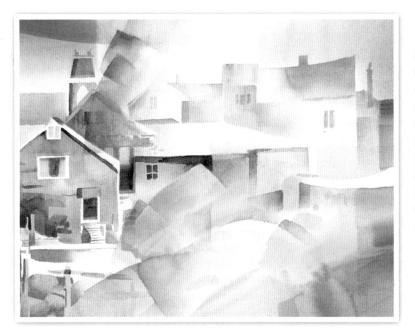

I began by painting some of the static shapes of the buildings with neutralized colors: Phthalo Green, Magenta, Turquoise Green and Permanent Green Light. I also painted the small area of the visible sky with graded washes in the two top corners. These graded washes lead you away from the corners and into the composition, and are good examples of how well the slant brush can lose the edge of a shape when only the long-hair end is dipped into color and the short-hair side holds only water. While these forms were still damp, I began the colorful foliage of the foreground tree. For these glazes I used well-diluted Permanent Green Light, Cadmium Yellow Lemon and Magenta on the light values but added Phthalo Green to the lowerright corner.

2 I further defined the character of the buildings using the same colors as before but in a little darker value. I also added some windows, doors and steps with my flat aquarelle brush. Using just Magenta and Phthalo Green, I painted the rocks and fence posts in the lowerleft corner. I also started to sharpen and develop the repetitive foliage units of the tree. By strengthening the contrast, depth was becoming more apparent.

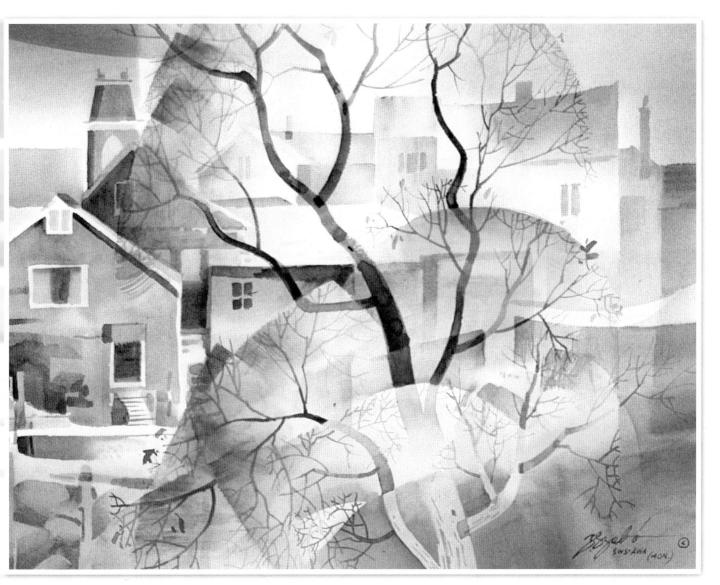

Binally, I turned my attention to the big foreground tree. At the bottom I started the trunk as a negative shape. As it moved higher, it turned positive and got darker as well beyond the filtering light of the pale yellow foliage shape. The powerful contrast of the skeleton of the tree clarified its location in space. I painted the small branches and twigs with the dominant color of the foliage they were part of. These thin lines and the few leaf shapes were painted with my rigger. The strength in the painting comes from the harmonious relationship in color as well as in value of the softly blended, yet contrasting, shapes.

Peace Town

13¾"×18" (35cm × 46cm) Noblesse cold-pressed paper Collection of Scott and Cindy Parker

Step-By-Step Misty Day Wet-into-Wet Reflections

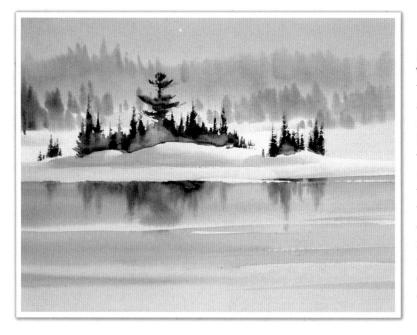

I started by wetting the top third L of the paper, making sure that it was saturated and shiny. With my 2-inch (51mm) slant bristle brush, I painted the sky with a combination of Raw Sienna and Cobalt Blue. Into this wet background, I painted the two rows of distant, misty evergreens. After this wash dried, I painted the dark silhouette of the evergreens on the islands, using a dark, very liquid wash of Turquoise Green, Burnt Sienna and Magenta. I painted the area fast enough to allow the wash to stay wet. Then I changed to my aquarelle brush and charged the wash with wet, pure colors in different spots: Magenta here, Raw Sienna there and a bit of Cobalt Blue. too, giving the shapes exciting color variation.

Now it was time to establish the shapes of the melting snow puddles. I filled my soft slant brush with a medium-value gray mixed from Cobalt Blue and Burnt Sienna, and brushed on the horizontal shapes fast but let the edges stay broken like snow. Immediately into this wash I painted the dark, blurry reflections in a lighter value than the trees themselves, but darker than the puddle colors. I repeated the first glaze near the bottom, showing horizontal sharp edges as well as some soft ones. For the finishing touches, I completed the dry-brushed branches on the trees with my little rigger.

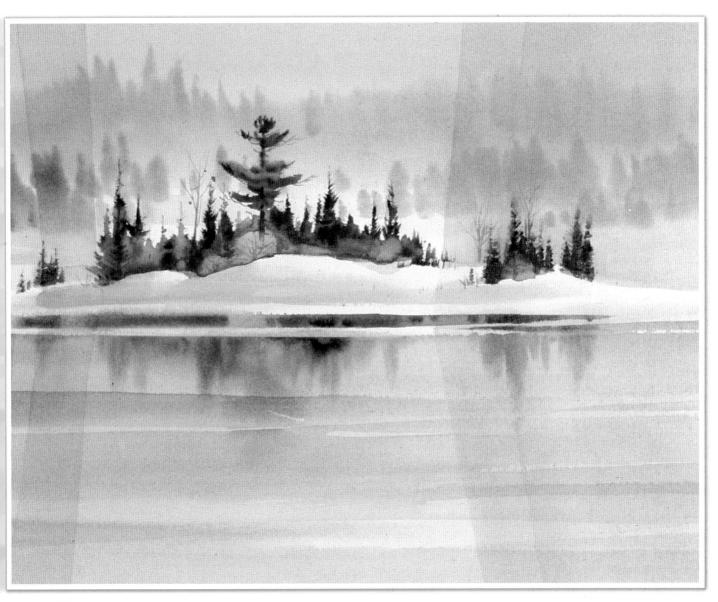

B I felt that the overwhelming horizontal dominance of the large shapes needed a little boost, so I designed some light glazes over the two sides to attract the viewers' attention and to increase the impact of the whites and the bright colors in the dark shapes. I lightly brushed on these glazes with my soft slant brush in a wet condition, passing over the dry details only once. Repeated passes may blue or remove the otherwise dry colors. With these last pale glazes, the personality of the composition also gained individuality.

Winter Vanity

 $13\frac{3}{1} \times 18$ " (35 cm $\times 46$ cm) Noblesse cold-pressed paper Collection of Patricia B. Floyd

Step-By-Step **Fallen Timber** Emphasizing Texture

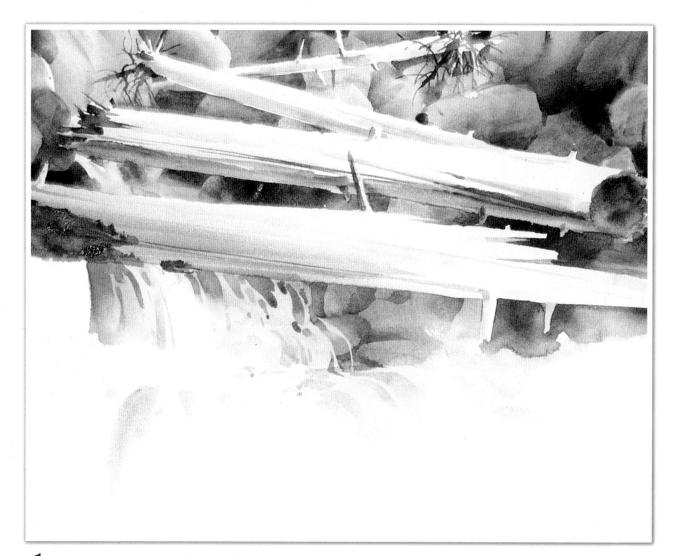

L Starting on dry paper, I painted around the negative shapes of the crisscrossing logs, using my 2-inch (51mm) soft slant brush that holds a lot of water and has a sharp point on its long-hair end. The turquoise wash for the water was a mix of Ultramarine Deep and Phthalo Green. On the bleached logs I added some Raw Sienna.

With my no. 8 round Essex brush, I added darker glazes to the flowing water indicating movement with the rolling shapes. Ultramarine Blue, Phthalo Green and a touch of Raw Sienna were my colors. For the base washes of the rocks, I mixed Burnt Sienna, Ultramarine Deep and Magenta in varied combinations. The sharp edges were left alone, but I lost the blended edges with a 1-inch (25mm) slant bristle brush. I also built more contrast on my logs by darkening the shaded sides, the broken ends and the dark roots with my no. 3 rigger.

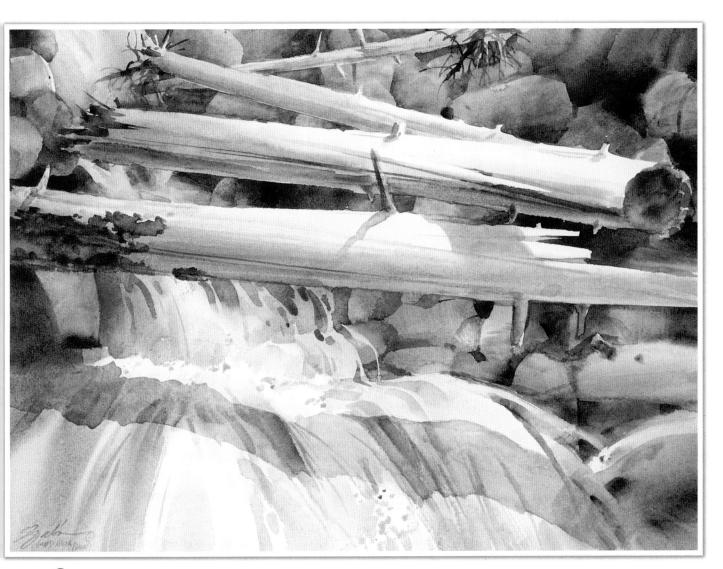

2 Next, I concentrated on the texture and details. The lower part of the waterfall and the lower rocks were painted similarly to the upper ones, but the shapes were increased in size to show perspective. I also shaded the distant falling water, the rocks and the far end of the logs with a dark glaze of Phthalo Green, Ultramarine Deep, Magenta and a touch of Burnt Sienna. I used the same colors to paint the cast shadows on the logs as well as on the falling water in my foreground. For these glazes, my 2-inch (51mm) soft slant brush was ideally suited, because it holds lots of liquid and my colors had to be light in value and wet.

In a Jam

13¾"×18" (35cm × 46cm) Noblesse cold-pressed paper Collection of Ruth and Jack Richeson

Step-By-Step

Fishermen's Shacks Negative Shapes as Focal Point

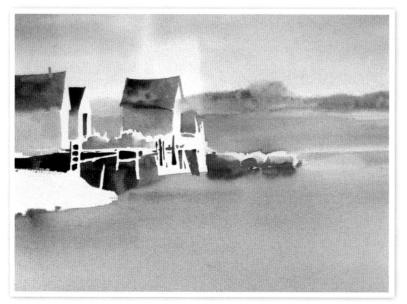

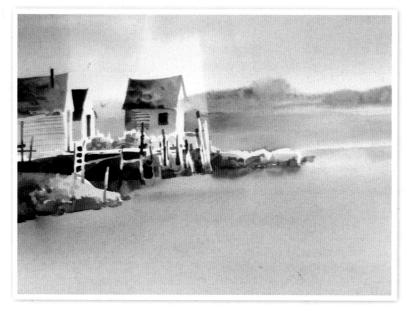

The background was painted L fast enough with large wet washes to achieve a wet-into-wet effect. For the sky, the distant trees and the water, I used a delicately varied combination of Cobalt Blue, Verzino Violet and Raw Sienna. The razor-sharp edge and fine-pointed tip of my soft slant brush allowed me to paint around the white parts of the structures in the middle ground. When the background dried, I switched to my ³/₄-inch (19mm) aquarelle brush and painted the roots and walls of the buildings as well as the rocks and the dark space under the platform. Then, I charged them with individual colors while the washes were fresh and wet, creating color excitement. The white negative shapes now took on the distinctive characteristics of light structures.

2 I continued with further light washes, detailing the rocks, the wooden structures, even the texture on the buildings' walls with my aquarelle and rigger brushes. The dark values of these shapes were achieved with separate glazes over dry washes to allow more variations in color, value and texture.

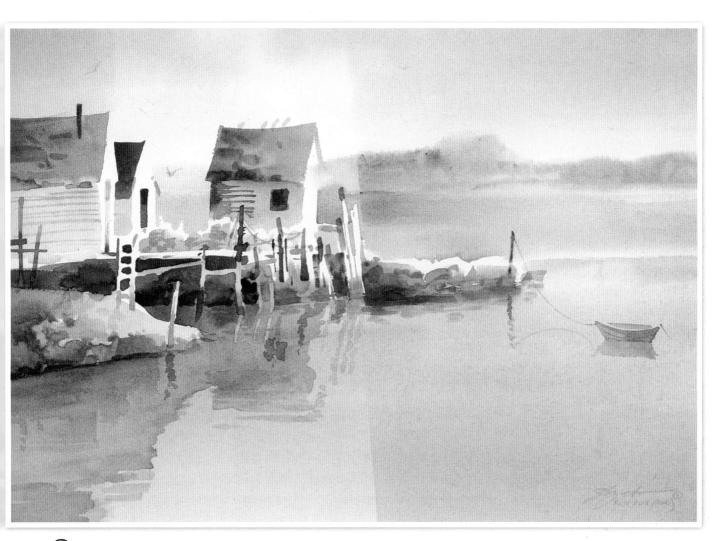

Finally I was ready to paint the reflections. Remember, reflections must relate to the reflected objects as you have painted them. For the color of my reflections, I used the colors of the reflected objects added to the local color of the water, which was a medium-value gray. These colors were mixed with Crimson Lake, Raw Sienna and Cobalt Blue.

To balance the overwhelming strength of the left side of the composition, I tied a little dory to the rocky point. It and its reflection added a touch of interest to the right side. To emphasize the whites of the focal point, I finished the painting with a very delicate, pale vertical glaze over the right and the left sides. This delicate curtain effect added a personal accent to the painting that is purely emotional in nature.

Fisherman's Sunday 13¾" x 18" (35cm × 46cm) Noblesse cold-pressed paper

Step-By-Step Sand Dunes Granulating Washes

1 I thoroughly saturated my paper with water. With my 2-inch (51mm) soft slant brush, I worked in my dark sky. The blending of the edges was controlled by the timing and the proper amount of water in the brush. I also painted the water exposed behind the carefully protected edges of the dunes. My colors were Turquoise Green, Permanent Green Light and Raw Sienna. As the horizon touched the sky, the paint was barely moist so the edge is a little soft.

2 Because the paper had dried, I moistened the white foreground with clear water. With my 2-inch (51mm) soft slant brush loaded with a rich mixture of Raw Sienna and Ultramarine Deep (two very heavy sedimentary colors), I painted the very wet washes of the sand, leaving the contrast to the whites in the middle ground. These washes had to be painted with fast, determined brushstrokes and then left alone so that the separation of the granulating colors was not disturbed.

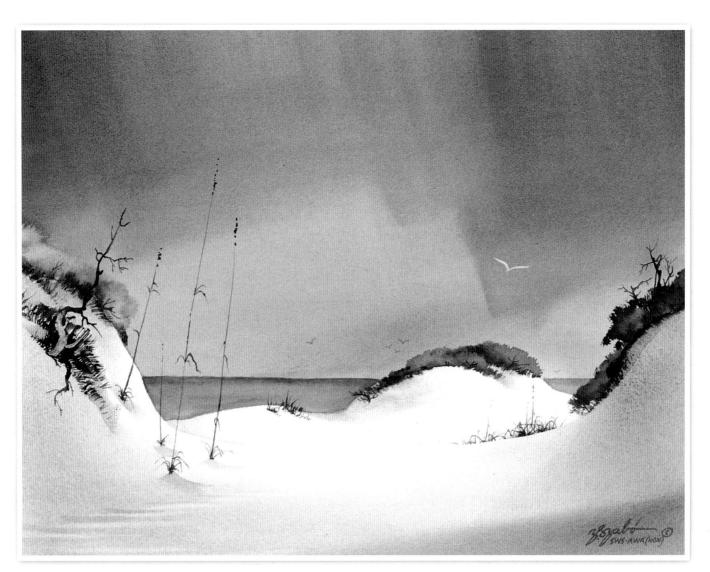

B I switched to my 2-inch (51mm) slant bristle brush to paint the patches of shrubs at the tops of the dunes, using plenty of Raw Sienna, Permanent Green Light, Ultramarine Blue and Turquoise Green.

After these larger green shapes were secure, I switched to my small rigger brush for the remaining calligraphic details. The delicate shapes of the sea oats and the broken-down tree skeletons were worked with Raw Sienna, Verzino Violet and Turquoise Green. Next, I proceeded with the rippled sand in the left foreground. First I wet-lifted the light sides of the ripples, then painted in the darker sides with the previous sand color. Finally, I lifted out the white gull by using a masking tape stencil on the dry surface and wetlifting the exposed shape of the bird. I blotted off the wet color immediately and then removed the tape slowly and carefully to avoid tearing the paper surface. Scouting 13¾" × 18" (35cm × 46cm) Noblesse cold-pressed paper Collection of Jerry McNeill

Step-By-Step **Forest Rapids** Wet-into-Wet Technique

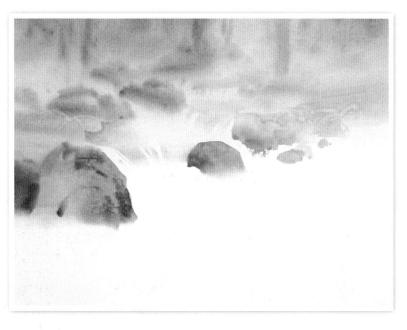

I saturated the paper with water, then spread a light wash of Cobalt Blue and Raw Sienna along the top area. I used my 2-inch (51mm) soft slant brush, moving it horizontally from one side of the paper to the other, back and forth. As I expanded the color downward on the wet paper, I gradually lost color completely. Switching to my aquarelle brush, I dropped in the distant tree and rock shapes. In the middle, I painted the two larger rocks with Permanent Green Light, Magenta, Cobalt Blue, and a little Burnt Sienna and splattered their wet shape with clear water to texture them.

2 After the paper dried, I worked on the larger rocks and trees using a slightly darker color mixed with Burnt Sienna, a little Magenta and the dominant Cobalt Blue. I dropped in the two darker trees with my aquarelle brush. My darkest color was mixed from Burnt Sienna, Turquoise Green and Magenta and wet-charged with Permanent Green Light, Cobalt Blue and Raw Sienna. I also painted the little shrub in front with the same colors.

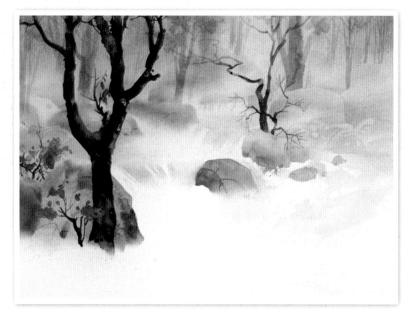

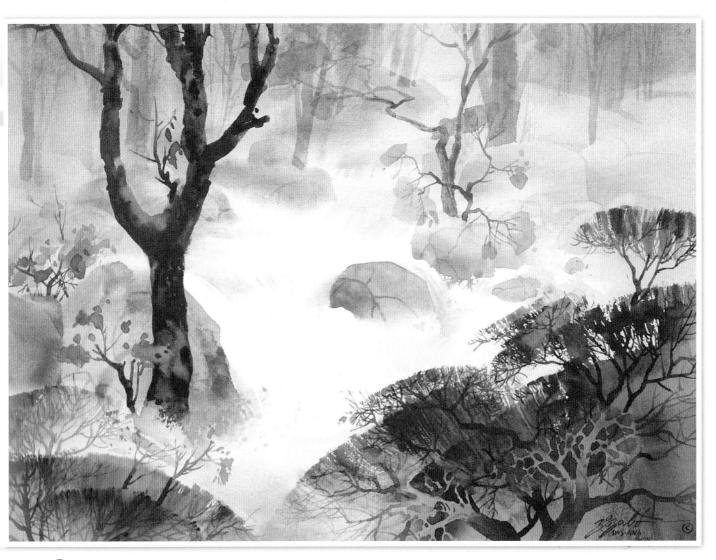

3 To complete the illusion of misty distance, I had to darken my foreground. I painted the drybrush foliage to the shrubs with my 2-inch (51mm) slant bristle brush, using dark mixes of Burnt Sienna, Turquoise Green and Permanent Green Light. I also enhanced the warmth of the big rock behind the large tree with a light glaze of Magenta. The rough water under the big rock is a blended wash of Cobalt Blue and some Burnt Sienna. As this wash was drying, I splattered clear water droplets into it to indicate bouncing water beads. Because the composition is dominated by curvilinear shapes at the bottom and static shapes at the top, the illusion of distance is a little clearer.

Forest Rapids

 $13\frac{3}{4}$ " $\times 18$ " (35 cm $\times 46$ cm) Noblesse cold-pressed paper Collection of Ruth and Jack Richeson

Step-by-Step Mountain Meadows Palette Knife Technique

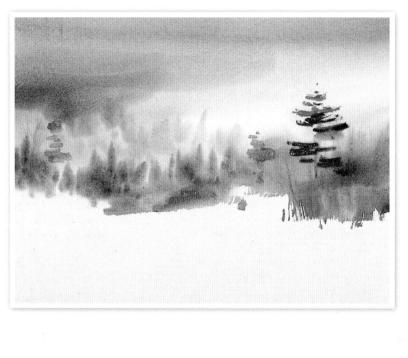

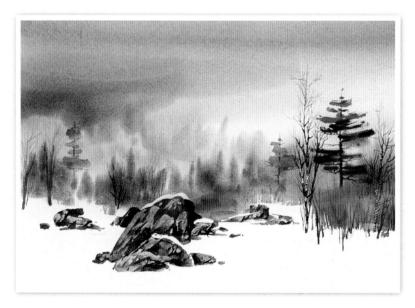

On thoroughly wet paper, I washed in the dark sky with my 2-inch (51mm) soft slant brush loaded with a combination of Burnt Sienna, Ultramarine Blue and some Turquoise Green. Into the bottom of this wet wash, I added the distant frosty evergreens with a lighter mix of Turquoise Green, Ultramarine Blue and a speck of Crimson Lake. While the paper was still very wet, I painted in the darker and warmer trees in the middle ground, utilizing five colors varied in their dominance: Turquoise Green, Burnt and Raw Sienna, Ultramarine Blue and Permanent Green Light. For the dark green foliage of my tallest pine trees, I held the slant bristle brush sideways and just touched the damp surface with the heavily pressed edge.

) Onto the dry surface I painted 🖌 the dark silhouette of the rocks with Burnt Sienna, Ultramarine Blue and Turquoise Green and some Crimson Lake in varying dominance. I painted these shapes in a thicker consistency than normal and immediately knifed off the lighter shapes on the rocks with my palette knife. This exciting texture is entirely the result of quickly applied paint and the fast knifing that followed. I also painted the delicate trees with my rigger brush filled with a dark combination of Crimson Lake, Burnt Sienna and Turquoise Green.

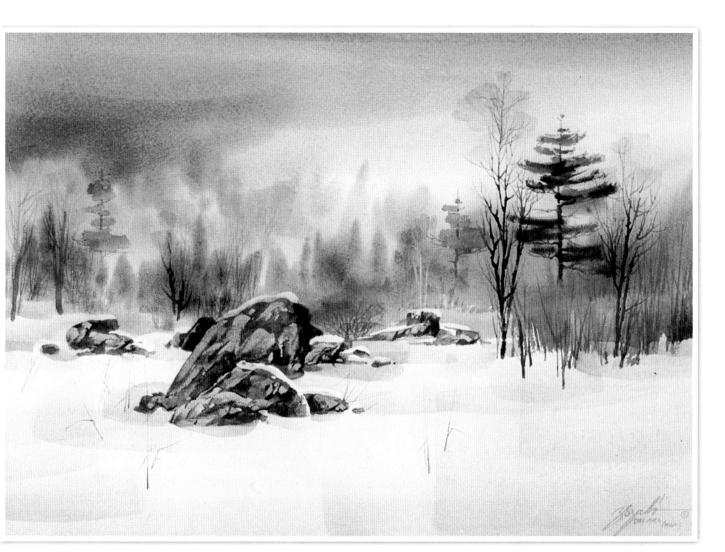

3 Next, I shaded the hollow dips in the snow with the lost-and-found edge technique. I used my ¾-inch (19mm) aquarelle brush to apply the smaller washes mixed from Ultramarine Blue, Raw Sienna and a touch of Turquoise Green. I did the pale tones representing small twigs at the tops of the deciduous trees the same way, but left the top edges sharp. I completed the painting with the repetitive soft shapes in the foreground snow.

Snow Turtles 13¾"× 18" (35cm × 46cm) Noblesse cold-pressed paper Step-by-Step

Trees Idealized Design

I started by wetting part of L the paper with just a touch of Cobalt Blue and Titanium White mixed wash, carefully avoiding the white paper behind the larger tree. While these washes were still wet, I applied the faint, distant evergreens with a mix of Cobalt Blue and a little Burnt Sienna. Next, I painted the rhythmical, curvilinear shapes of the foliage clusters with colors dominated by Permanent Yellow Deep and accented with Cobalt Blue and Magenta. I applied these basic shapes on a dry surface, and where the brushstrokes overlapped another already dry shape, the colors doubled up in value. I designed the larger tree's trunk and limbs following the same principles. The result is an exciting design that shows off watercolor's natural luminous glow.

2 I continued with the rest of the branches, connecting the abstract foliage clusters with my ¾-inch (19mm) aquarelle brush for the wider limbs and my rigger for the smaller branches. On the lower shrubs, I treated some of the base branches as negative shapes by painting around them and leaving the background next to them darker. I also dropped in a few leaf shapes to indicate small accents. My colors were the same as in step 1.

B I was determined to preserve a sufficient amount of white paper next to my center of interest, and to let this shape serve as a static complement to the tree's curvilinear design. The pale blue shapes along the top-left edge of the sky and the top-right corner echo the rhythm of the foliage. The shapes at the bottom of the painting, with their zigzagging straight edges, lead to the middle ground where the center of interest is located. I painted these shapes with the 2-inch (51mm) slant bristle brush using Cyanine Blue and Burnt Sienna.

Autumn Couple $13\frac{3}{4}$ " × 18" (35cm × 46cm) Noblesse cold-pressed paper Collection of the artist

Step-by-Step Quiet Harbor Contrast and Reflections

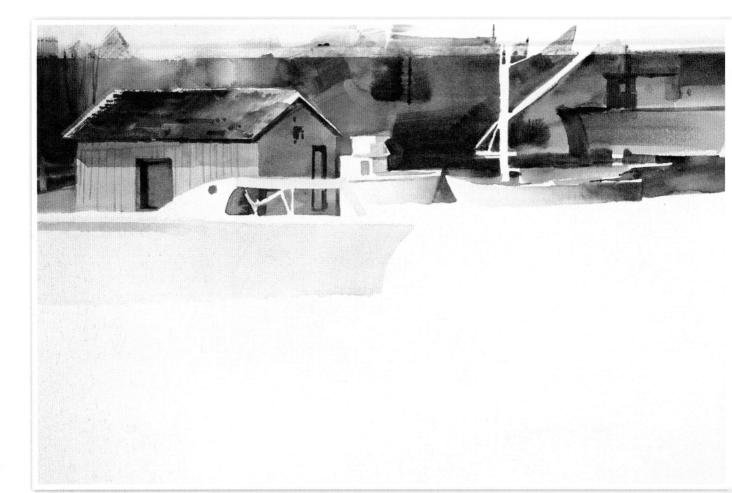

1 began by roughing in the background and the boats with my ¾-inch (19mm) aquarelle brush, carefully painting around the white negative shapes. The white boats' hulls were modeled with a blue-gray color mixed out of Cobalt Blue and Raw Sienna, with a touch of Phthalo Green only on the boat with the white mast. The neutral dark background and the sunlit building's roof are a Phthalo Green and Magenta combination applied in varying dominance. I also charged this wet wash with a light value of Permanent Green Light and Raw Sienna to indicate future trees. For the foreground building's walls, I started with a pale Raw Sienna wash and, after it dried, I glazed the shadow with Phthalo Green and Magenta in light values.

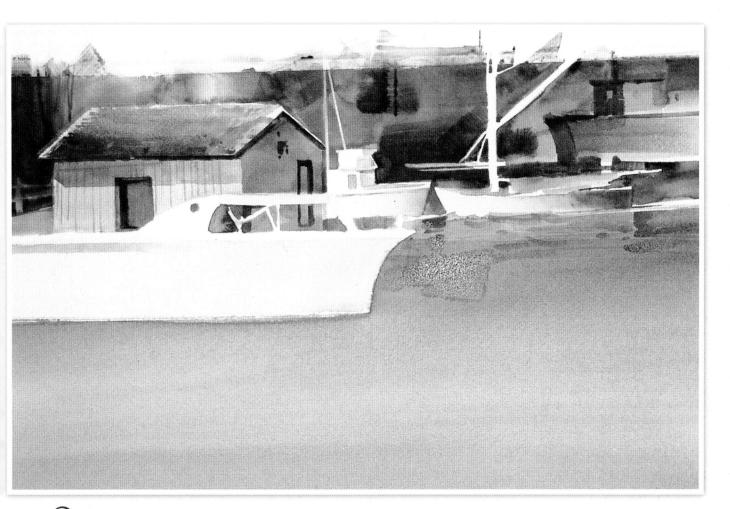

2 Whenever your subject matter will include reflections, it is a good idea to first design all the elements in a painting that can influence the reflections, because all reflections must relate to their originating objects. To paint the water and the reflections where they belong, I washed in the basic local color of the water with a very wet combination of Cobalt Blue and Raw Sienna. Notice that at the bottom half of the water, I let the Raw Sienna dominate to show the sandy bottom. Near the smaller boats, I painted a little darker glaze around the reflections to hint at wave movement.

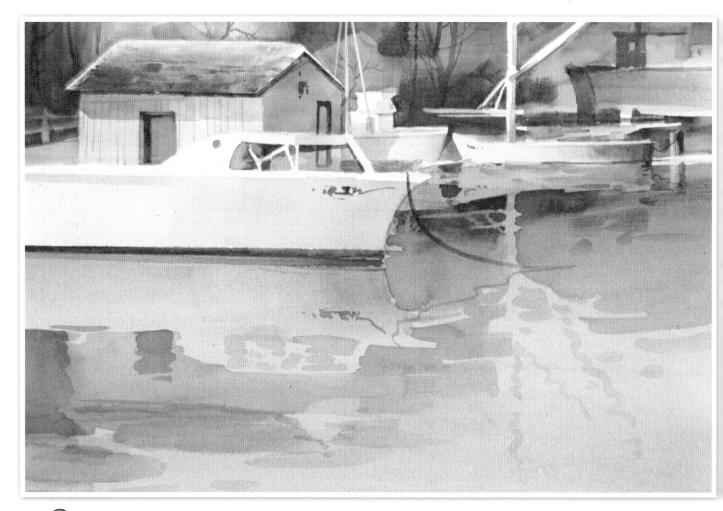

B After my first wash dried, I raised the top edge of the paper to slant the surface a little. With the same color combination, I glazed on the second value of the water, avoiding the reflections of the light images. I made sure that the edges were established playfully as wiggly edges to indicate wave movement. I added a third value to show where really dark images reflected. Notice that the reflections of the white boats are a little darker than the value of the boats themselves, but the dark shapes in the background reflect a little lighter than their own value.

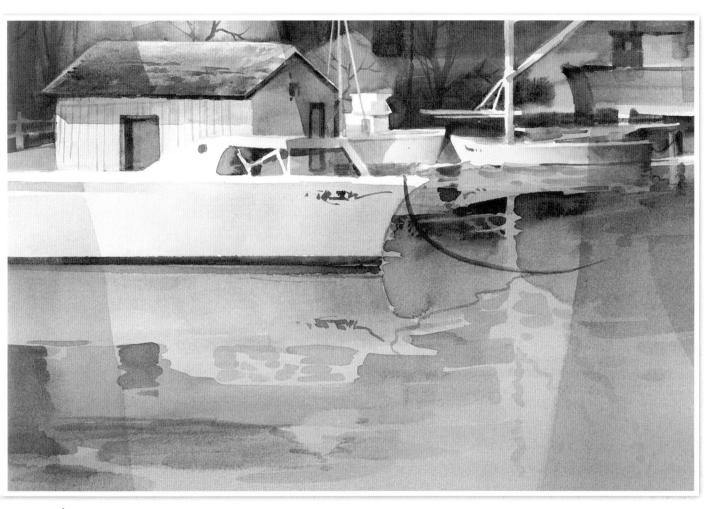

4 For all intents and purposes, the painting was finished. However, I felt the need of a unifying glaze to strengthen the composition on a more personal level. I glazed on the large transparent shapes over the dry details with just one pass, using my soft slant brush loaded with a wet mix of Magenta and Phthalo Green in a very light value. The neutrality of this color enhanced the color contrast in the untouched sections and boosted the impact of the whites, while adding to the personality of the painting.

Resting Harbor

13¾" × 18" (35cm × 46cm) Noblesse cold-pressed paper Collection of Vicki Cooper

Step-by-Step Daffodils Backlighting

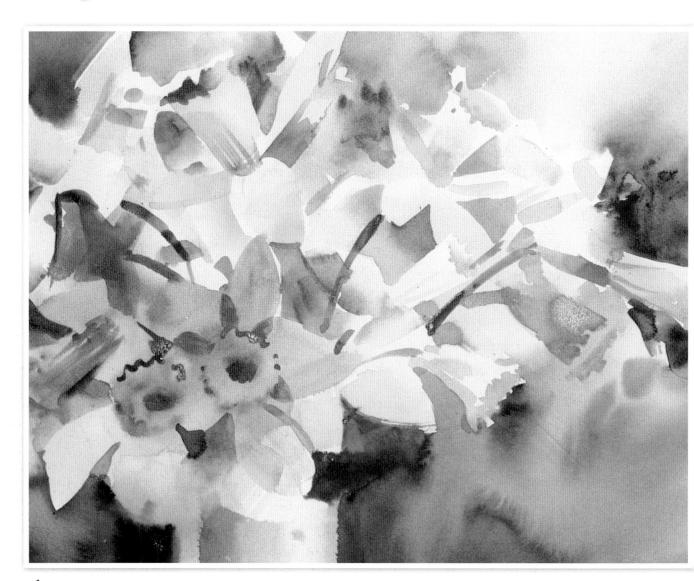

1 I started on dry paper, but to assure a loose, liquid technique, I painted with lots of water in my washes. This way I encouraged the colors to mingle, showing freely flowing washes with individual color dominance. These washes were applied with the 2-inch (51mm) soft slant brush. I carefully protected my negative shapes, especially the white silhouettes. The light flower shapes were dominated by Cadmium Yellow (Lemon) and Permanent Yellow Deep and a touch of Burnt Sienna. I defined the background with cooler colors. The darkest of these were dominated by Phthalo Green, Magenta and some Burnt Sienna. The overlapping values created a textured excitement that subtly enhanced the painting's tactile qualities.

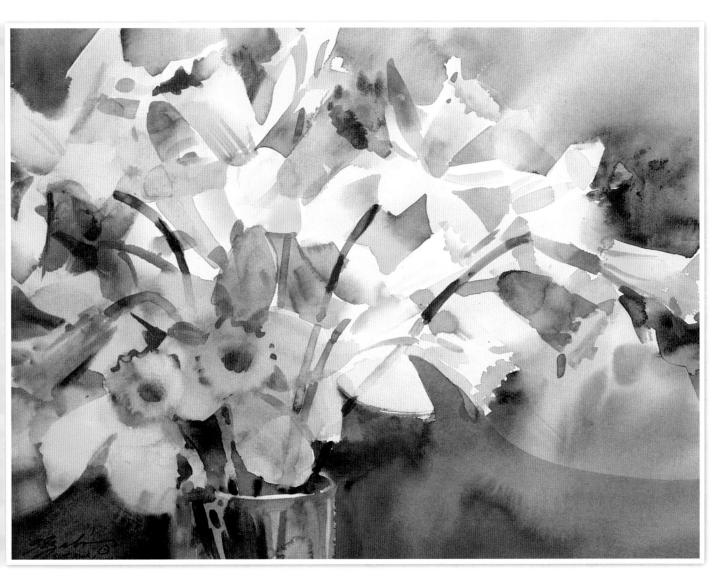

2 The dramatic illusion of strong backlighting is due to the importance of the carefully protected white negative shapes. To make the cool, dark background at the bottom of the painting even more dramatic, I glazed a light coat of Phthalo Green and Magenta over the dry first wash on both sides of the vase. For the vase details, I used Cobalt Blue, Phthalo Green, Burnt Sienna and a touch of Magenta. The highlights on the glass are negative shapes as well as lifted out. The daffodil petals' texture is a notable result of the sedimentary interaction of the Cadmium Yellow (Lemon), the Cobalt Blue and the Burnt Sienna in a very wet wash.

Golden Spring

13¾" × 18" (35cm × 46cm) Noblesse cold-pressed paper Collection of Kelly and Rhea Green

Index

Active imbalance, 42 Angle of incidence, 32 Angle of reflection, 32 Autumn Colors, 118–119

Back runs, 47, 75, 86–88, 91, 96, 101 Background Forest, 47, 86–87 Backlighting, 138–139 Balance, 42 Blockx palette, 23 Branches, Pine, 48, 60 Breeze patterns, 34 Brush blotter, 11 Brush handle scraping, 48, 58–59, 78–79, 97, 102 Brushes, 10, 11

Charged Washes, 47, 96 Charging a wash, 47, 66, 86-87, 96-97, 102, 105 Clouds Cumulus Clouds, 54 Dramatic Clouds, 56-57 Stratus Clouds, 55 Wispy Clouds, 49, 52-53 Cobweb, 49, 83 Colorful Darks, 47, 48, 97 Colors. See also Pigments analogous, 42 complementary, 42 lifting out color, 49 local color, 26, 31 sedimentary, 17 temperatures, 43 transparent, 14 Complementary colors, 42 Composition and design, 36-43 composing, defined, 37 graphic symbols, 39 path of vision, 40-41 planes, 42-43 space, illusion of, 38 Corkscrew path, 40, 41

Demonstrations, 8, 108–139 Design, 6. *See also* Composition and design idealized, 132–133 Directionals, 39 Dominance, 20, 21

Edges

composition and design, 41 controlling edges, 118–119 lost and found edges, 46. *See also* Lost and found edges

Fishermen's Shacks, 124–125 Flowers Birthday Wish, 95 Daffodils, 138–139 Flowering Trees, 64–65 glazing with staining colors, 110–111 Golden Spring, 138–139 Fog, Heavy, 48, 49, 78–79 Forest, background, 47, 86–87

Glazing and lifting, 112–115 Glazing with staining colors, 110–111 Granulating washes, 126–127 Graphic symbols, 39

Ice

Ice on Trees, 90 Icy Creek, 112–115 Idealized design, 132–133 Illusion of movement, 43 Illusion of space, 38 Isolated elements, 40

Leading the eye, 39 Lifting out color description of technique, 49 techniques for painting, 52–53, 83, 102 Line or two planes, 42 Local color, 26, 31 Lost and found edges, 46, 68, 75–77, 80–81, 88, 94–95 Luminous opaque colors, 49, 78–81

Maimeri palette, 22 Mist, 46, 49, 80–81 Misty Day, 120–121 Mountains Mountain Meadows, 130–131 Sunlit Mountain Tops, 107 Movement, illusion of, 43

Narrow horizontal planes, 43 Narrow vertical planes, 43 Negative Shapes, 46, 94–95, 124–125 Nonstaining colors, 19, 46

Opaque colors, 15, 49, 78–81 Overall patterns, 40

Paints, 10, 11 Palette Blockx, 23 Maimeri, 22 tools, 11 Winsor & Newton, 23 Palette knife, 130-131 Palette Knife Trees, 48, 103, 58-60, 66-67, 75, 89, 98-99, 100, 102-103 techniques for use, 48 tools, 11 Papers, 10 Parallel planes, 43 Path of vision, 40-41 Path to the distance, 41 Pigments, 6. See also Colors brands, 13 dominance, 20, 21 nonstaining, 19, 46 opaque, 15, 49 palettes, 22-23 reflective, 16 sedimentary, 17 staining, 18, 110-111

staining dominance, 21 transparent, 14 Planes, 42–43, 84–85

Quiet Harbor, 134-137

Reflections

imperfect reflectors, 26 knowledge of, 6 perfect reflectors, 26 Puddle Reflections, 69 rules. See Rules of reflection tonal value of reflections, 30 wet-into-wet, 120-121 Reflective colors, 16 Rocks Jagged Granite Rocks, 47, 48, 66 Rock Setting, 47, 48, 49, 102 Rounded Glacial Rocks, 48, 67 Rolling Snowbanks, 48, 89 Rolling Surf, 46, 68 Rules of reflection, 24-35 angle of incidence, 32 angle of reflection, 32 breeze patterns, 34 light subject against dark background, 35 local color of the water, 31 object must reflect directly below itself, 27 object tilting away from you, 28 object tilting toward you, 28 surface reflections, 33 tonal value, 30 vantage point, 29 waves, characteristics of, 26

Sand Dunes, 126–127 Setting Sun, 92–93 Shaded planes, 43 Similar values, 43 Simplified Planes, 84–85 Snow

Falling Snow, 74

Frozen Assets, 112-115 Rolling Snowbanks, 48, 89 Shadows on Snow, 46, 70-71 Sunlight on Snow, 72 Trees in Heavy Snow, 46, 47, 48, 75 Warmly Lit Snow, 46, 73 Winter Friends, 77 Winter Island, 46, 47, 88 Winter Vanity, 120-121 Young Spruce in Snow, 46, 76–77 Space, illusion of, 38 Staining colors, 18, 110-111 Staining dominance, 21 Staining texture, 116-117 Sun, setting, 92-93 Sunlight lifted sunlight, 116-117 Sunlight on Snow, 72 Sunlight on Wood, 82 Sunlit Mountain Tops, 107

Surf, 46, 68

Techniques, 8, 44-49 back runs, 47 brush handle scraping, 48 charging a wash, 47 lifting out color, 49 lost and found edges, 46 luminous opaque colors, 49 palette knife, techniques for use, 48 wet-and-blot lifting, 46 Texture emphasizing texture, 122-123 staining texture, 116-117 Tools, 10-11 Trees Background Forest, 47, 86-87 Birch Trees, 48, 58-59 Brush Handle Trees, 104 Fallen Timber, 122-123 Flowering Trees, 64-65 Frost on Trees, 47, 91 Glazed Tree Bark, 48, 100 Ice on Trees, 90

idealized design demonstration, 132–133 Lifted White Trees, 61 Palette Knife Trees, 48, 103 Pine Branches, 48, 60 Rough Tree Bark, 48, 99 Smooth Tree Bark, 48, 98 Soft Lifted Trees, 47, 105 Trade Wind, 57 Tree Impressions, 47, 101 Trees in Heavy Snow, 46, 47, 48, 75 Wet-into-Wet Evergreens, 106 Young Spruce in Snow, 46, 76–77

Values of planes, 43 Vantage point and reflections, 29 Vision, path of, 40–41

Wash. See also Charging a wash Charged Washes, 47, 96 granulating washes, 126-127 Water contrast and reflection demonstration, 134-137 Forest Rapids, 128-129 High Country, 87 Icy Creek, 112-115 Puddle Reflections, 69 Rolling Surf, 46, 68 Scottish Autumn, 63 Waves, 26, 34 Weeds, 62-63 Wet-and-blot lifting description of technique, 46 techniques for painting, 70-71, 73, 78 - 79Wet-into-wet, 120-121, 128-129 Wet-into-Wet Evergreens, 106 Winsor & Newton palette, 23 Wood, 82, 116-117. See also Trees Shadows on Wood, 116-117

A DAVID & CHARLES BOOK © F&W Media International Ltd 2011

David & Charles is an imprint of F&W Media International, Ltd Brunel House, Forde Close, Newton Abbot, TQ12 4PU, UK

F&W Media International, Ltd is a subsidiary of F+W Media, Inc., 10150 Carver Road Blue Ash OH 45242, USA

Text copyright © Zoltan Szabo 2011 Illustrations copyright © Zoltan Szabo 2011

Zoltan Szabo has asserted his right to be identified as author of this work in accordance with the Copyright, Designs and Patents Act, 1988.

All rights reserved. No part of this publication may be reproduced, stored in a retrieval system, or transmitted, in any form or by any means, electronic or mechanical, by photocopying, recording or otherwise, without prior permission in writing from the publisher.

A catalogue record for this book is available from the British Library.

ISBN-13: 978-1-4463-0124-1 ISBN-10: 1-4463-0124-9

Printed in China for David & Charles Brunel House, Newton Abbot, Devon

10987654321

Commissioning Editor: Freya Dangerfield Assistant Editor: Felicity Barr Design Manager: Sarah Clark

F+W Media publish high quality books on a wide range of subjects. For more great book ideas visit: www.rubooks.co.uk

Metric Conversion Chart		
To convert	to	multiply by
Inches	Centimeters	2.54
Centimeters	Inches	0.4
Feet	Centimeters	30.5
Centimeters	Feet	0.03
Yards	Meters	0.9
Meters	Yards	1.1

About the Author

Zoltan Szabo was born in Hungary in 1928 where he attended art school before he immigrated to Canada in 1949 and then to the United States in 1980. He was an artist, author and teacher, though he was best known for his watercolors. Through his seminars Szabo personally taught over 12,000 artists in the United States, Canada, Europe and even Saudi Arabia.

Zoltan Szabo was author of seven popular books including *Painting Nature's Hidden Treasures, Painting Little Landscapes*, and *Zoltan Szabo Watercolor Techniques*. Szabo was an associate editor of *Decorative Artist's Workbook* magazine and was featured in the magazines *American Artist, Art West* and *Southwest Art*, as well as in three books: 40 Illustrators and How They Work, *Being an Artist* and *Splash 2*.

Over 8,000 of Szabo's paintings are owned by private collectors in Australia, Belgium, Germany, Great Britain, Japan, Hungary, France, Netherlands, Norway, Russia, Sweden, Canada and the United States.

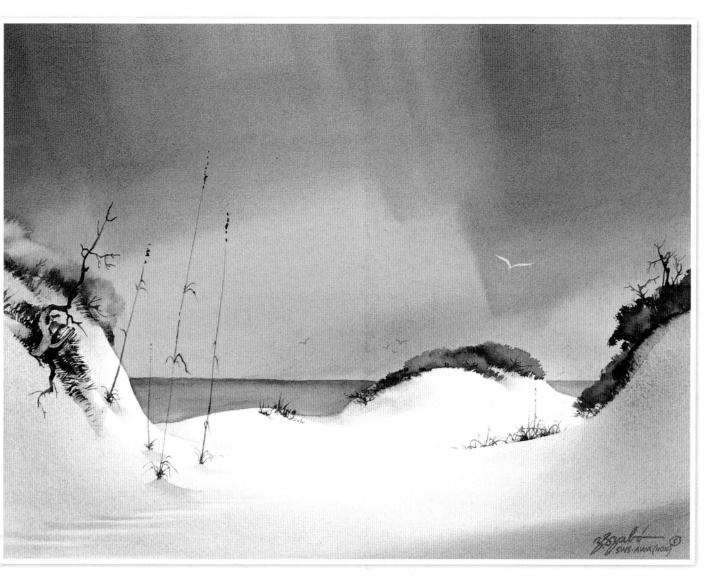

Scouting 13¾" × 18" (35cm × 46cm) Noblesse cold-pressed paper Collection of Jerry McNeill

Ideas. Instruction. Inspiration.

These and other fine North Light products are available at your local art & craft retailer, bookstore or online supplier.

Receive FREE downloadable bonus materials when you sign up for our free newsletter at artistsnetwork.com/Newsletter_Thanks

Find the latest issues of *Watercolor Artist* on news-stands, or visit artistsnetwork.com.

Want to see your art in print?

Visit **splashwatercolor.com** for upto-date information on future North Light competitions or email us at **bestofnorthlight@fwmedia.com** and ask to be put on our mailing list!

Splash: The Best of Watercolor

The Splash series showcases the finest watercolor paintings being created today. A new book in the series is published every other year by North Light Books (an imprint of F+W Media) and features nearly 140 paintings by a wide variety of artists from around the world, each with Instructive information about how it was achieved including inspiration, tips and techniques.

Gallery

Passionate Brushstrokes

Splash 10 explores "passion" through the work and words of 100 contemporary painters. With each windly reproduced modern-day masterpiece, insightful firsthand commentary taps into the psyche of the artist to explore where their passion comes ...

Watercolor Discoveries

 $g_{\text{plash}} \not = \text{holds its own as a visual showcase,} representing some of the best work being done in watercolor today. But of course, that's only the half of it. <math display="inline">g_{\text{plash}}$ is much more than a pretty face. In the same open, giving spirit that ha...